GAINSBOROUGH'S LANDSCAPES

GAINSBOROUGH'S LANDSCAPES

Themes and Variations

SUSAN SLOMAN

PHILIP WILSON PUBLISHERS
IN ASSOCIATION WITH
THE HOLBURNE MUSEUM

Published to accompany the exhibition
Gainsborough's Landscapes: Themes and Variations
at the Holburne Museum
24 September 2011 to 8 January 2012
and at
Compton Verney
11 February to 10 June 2012

The Holburne Museum
Great Pulteney Street, Bath, BA2 4DB
www.holburne.org
Registered charity No: 310288

© The Holburne Museum 2011

Philip Wilson Publishers Ltd, an imprint of I.B.Tauris & Co Ltd
Philip Wilson Publishers Ltd.
6 Salem Road
London W2 4BU
www.philip-wilson.co.uk

ISBN 978-0-85667-697-0

Distributed in the United States and Canada
exclusively by Palgrave Macmillan, 175 Fifth Avenue, New York NY 10010

Edited by David Hawkins
Designed in Adobe Caslon by Geoff Green Book Design, Cambridge
Printed and bound in China by Everbest

Front cover
River Landscape with a View of a distant Village
Thomas Gainsborough, *c.*1750.
Edinburgh, National Galleries of Scotland, NG2174

Contents

Foreword

THOMAS GAINSBOROUGH came to Bath as a portrait painter and it is as a portrait painter that he remains best represented in the city. Today his magnificent *Captain William Wade* hangs in the Assembly Rooms, and at the Holburne a wonderful group of half a dozen portraits, including the spectacular *Byam Family*, gives a sense of his development and of his range as a portraitist, particularly during the sixteen years he spent here.

But if Gainsborough's success in the city depended on what he had cause to call the 'curs'd face business' he turned to landscapes for enjoyment. In a famous and much-quoted letter to his friend William Jackson written from Bath he complained: 'I am sick of portraits and wish very much to take my Viol da Gam[ba] and walk off to some sweet Village where I can paint Landskips and enjoy the fag End of Life in quietness & ease.' Where portraits were Gainsborough's work, and enervating work at that, painting landscapes, the letter suggests, was pure pleasure.

We are thrilled that the Holburne should be mounting the first exhibition solely devoted to Gainsborough's landscapes in modern times. We are also thrilled that, thanks to the sensitivity and care of its curator Sue Sloman, it is a show that is not only beautiful but thought provoking. Above all, the exhibition reveals through Gainsborough's landscapes and drawings how he worked as an artist, how he thought and – if we accept his own estimation of his landscapes – how he enjoyed himself. As the title of the exhibition suggests, the works selected, and in particular his drawings, reveal an artist returning again and again to play variations on the same theme, embarking with his pencil or chalk on impromptu cadenzas, repeating particular motifs and ideas and reworking them in different keys throughout his life. In short they show the artist's mind at work, or perhaps at play.

An exhibition that wishes to make its points visually, through telling comparisons and juxtapositions, is even more dependent on the generosity of lenders than usual. We have been overwhelmed by the willingness of almost all lenders

asked to support this venture and we would like to thank them all. In particular we would like to thank the Hon. Simon Howard for the loan of the wonderful *Girl with Pigs*, one of the most significant of all Gainsborough's fancy pictures and one which has only rarely left the walls of Castle Howard. I would also like to thank all those who have helped make this exhibition possible, including the Friends of the Holburne, without whose support we would have no exhibition programme, and The Paul Mellon Centre for Studies in British Art which has generously supported this catalogue.

ALEXANDER STURGIS
Director, Holburne Museum

Author's acknowledgements

P UTTING THIS BOOK and exhibition together has been a joy and, above all, I would like to thank Alexander Sturgis, Amina Wright and Howard Batho for giving me the opportunity to work with them. The lenders have been prepared to go without their pictures for a considerable period of time, and, of course, without them there would be no exhibition: I hope that they will feel in some way rewarded by seeing their treasures shine in unfamiliar company. Enterprises of this kind involve the help of many people, and several stand out – Hugh Belsey, Lowell Libson and Andrew Wyld, who have been more than generous in sharing their knowledge. I would like to thank Brian Allen, Harriet Drummond, Emmeline Hallmark, Colin Harrison, Christopher Kingzett, Mark Pomeroy, Henrietta Ryan, Nicholas Savage, Kim Sloan, Sarah Taft and Christie Wyld who have helped and inspired me in a variety of ways. My late husband Ron Sloman encouraged me to take on this project at a very difficult time, and much is owed to him and to my family.

Gainsborough's Landscapes:
Themes and Variations

THE ARTIST John Constable said of the landscapes of Thomas Gainsborough (1727–88) that 'on looking at them, we find tears in our eyes, and know not what brings them'.[1] He was profoundly moved by Gainsborough's ability to conjure up 'the depths of twilight', 'the lonely haunts of the solitary shepherd' and other such 'simple' subjects, and by the painter's obvious empathy with the peasant men and women that inhabit his pictures. Constable was speaking to an audience at the British Institution in 1836. Today, in a more cynical age, few would admit to such open expressions of emotion, but the power of these pictures has endured and Gainsborough is still one of the best loved of all English artists.

Constable's understanding was based on a close examination of Gainsborough's work (he made a number of drawings in Gainsborough's style) and on a shared experience of the English countryside. With the passage of time it is harder to enter Gainsborough's skin in the way that Constable could, but visiting an exhibition is the best means of gaining a deeper appreciation of an artist we think we already know. There is no substitute for seeing works first-hand, their true size, colour and texture untainted by the medium of print on paper or the artificial brightness of the computer screen. For reasons of conservation we are now obliged to display pictures under restricted light, but this should not necessarily be seen as a disadvantage. Many of the drawings were made at night, by candlelight, and the paintings were designed to hang in rooms that by present-day standards would be thought gloomy. The softness of effect in Gainsborough's art that was once so much admired is indeed negated by overly efficient modern lighting.

Gainsborough was born in Suffolk and began his career in London and East Anglia. He came to Bath in the late 1750s as a portrait painter, working first from a house in Abbey Churchyard and then from one in the Circus. While portraiture earned him a living, landscape painting was his pleasure and he regularly rode out into the local countryside to collect ideas. So successful was his portrait business

that he did not move from Bath to London until 1774, making his stay in the city the longest by any major artist. Gainsborough's great works are now dispersed throughout Britain, Europe and the United States, and there are even one or two important pictures in Japan (fig. 6). Happily *Mr and Mrs Andrews*, *Mr and Mrs Hallett* (the 'Morning Walk'), *The Watering Place* (no. 20) and *The Market Cart* remain as ambassadors for British art in the National Gallery in London. Between the 1960s and 1980s the late John Hayes tackled the daunting task of cataloguing the drawings and landscape paintings. Hayes curated several major exhibitions, setting out for the first time a credible chronology for these works. More recent exhibitions at the Tate in 2002 and in the United States in 2005–6 have presented the artist in the context of the pioneering public art exhibitions in London (which all began in the 1760s) and of the eighteenth-century cult of sensibility, opening our eyes to the competitive spirit and the benevolent disposition of this extraordinary man.[2] Another way of considering Gainsborough's work, and the one which is chosen here, is to look at how his pictures are composed. When, at the end of his life, the artist himself reassessed *Cornard Wood* (fig. 1) painted four decades earlier, the only real fault he found was that it contained 'very little idea of composition'. 'The touch and closeness to nature in the study of the parts and <u>minutiae</u>', he wrote, 'are equal to any of my later productions'.[3]

Composition is a word used to describe the process of writing music as well as the making of drawings and paintings, and since Gainsborough played several instruments and spent more time in the company of musicians than of painters, the analogy between the two creative processes is particularly apt; hence our title 'Themes and Variations'.[4] Six themes have been selected. For each of these, a key painting from every period of his life acts as a centrepiece. Grouped next to each painting are variations on the same theme in the form of drawings or prints. The key paintings are arranged chronologically; the supporting works that surround each of them are sometimes earlier, sometimes later in date. The drawings are not necessarily studies for oils, but are often restatements of the same idea, given a fresh emphasis or new character.

A working balance between portraiture and some other more imaginative branch of painting was not easily achieved in the eighteenth century, especially if the artist was good at capturing likenesses. The lucrative profession of 'face painting' took Sir Joshua Reynolds (1723–1792), Gainsborough and George Romney (1734–1802) to the top of the tree in the London art world, but none of these men wished

(opposite)
Fig.1 *Cornard Wood, near Sudbury, Suffolk*
Oil on canvas, 122 x 155 cm
© The National Gallery, London. Bought (Lewis Fund), 1875

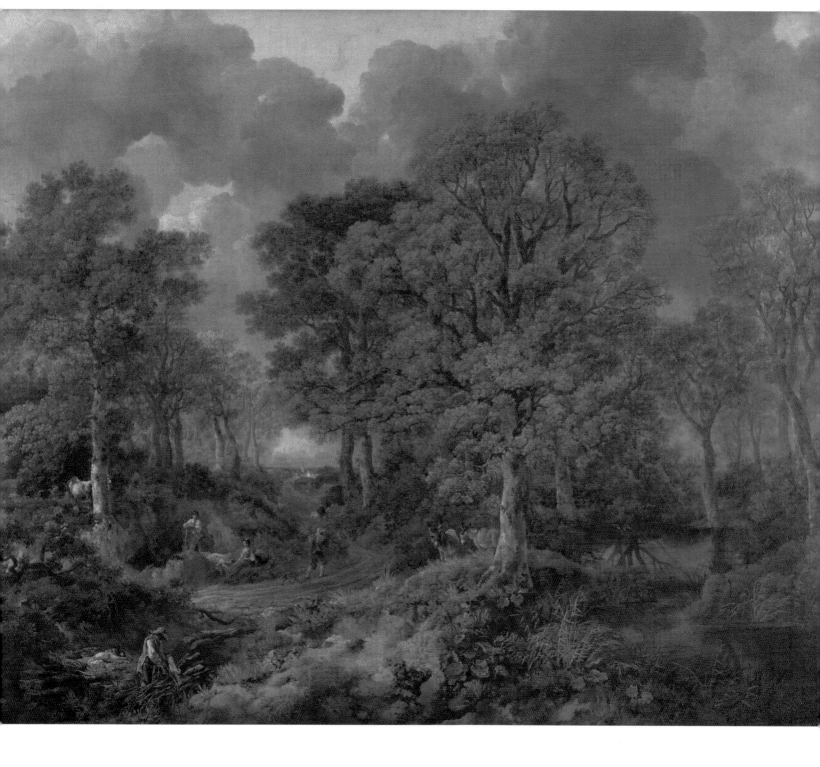

to spend all his time painting portraits. Reynolds and Romney aspired to be history painters and all three men devoted some of their time to 'fancy' subjects.[5] Romney, after twenty years of portraiture, longed for the opportunity to concentrate on what he called 'those delightful regions of imagination'.[6] Romney's exact contemporary Joseph Wright of Derby (1734–1797) was the fourth great all-round artist of the period. He painted a significant number of landscapes, but his preoccupation with the practical concerns of portraiture is illustrated by an entry in his account book where he lists 'A half length Landscape of a Cottage Scene', meaning a cottage scene painted on a fifty by forty-inch canvas, the standard format for a half-length figure.[7] Richard Wilson (1714–1782), a slightly older man than the rest, began as a portrait painter but concentrated on landscape after his visit to Italy in the mid century. He was acknowledged to be the leading artist in the field before Gainsborough. He and the Irishman George Barret (1732–1784) were among the very few landscape specialists to be made foundation members of the Royal Academy in 1769.

When Gainsborough was born, landscape painting in England was in its infancy. In Continental Europe, where the art had flourished in the seventeenth century, there was such a dearth of talent that it was said in 1730, 'There are no longer any landscape painters… Perhaps someone will come, who will take up this part, which is almost extinguished'.[8] The English aristocracy and landed gentry, who loved their country estates, and country pursuits in general, had always collected landscape paintings. At the beginning of the eighteenth century the pictures they acquired were necessarily old and imported, and they were slow to turn their attention to contemporary British art. Even the most able of the new wave of native painters who were active in the 1730s and '40s had to diversify in order to survive. John Wootton (1682–1764) successfully combined sporting painting and landscape, while George Lambert (1700–1765) painted stage sets to augment his income from landscapes. Samuel Scott (1702–1772) painted marine subjects and landscapes. Gainsborough would have grown up in the knowledge that there was a limited market for this art, but he was naturally inclined towards the pure visual pleasure that was to be had from landscape rather than the more complex intellectual rewards that derived from historical or literary subjects. He was not raised in a bookish household, but spent his childhood exploring the countryside and was said to hold in his mind every clump of trees, hedgerow and fencepost in the vicinity of his birthplace.[9]

As soon as he could draw, Gainsborough began to commit these things to paper, thus setting in train what was to become a lifelong passion for drawing. He and George Romney were to be the most productive draughtsmen of their generation. Both used drawing to record things seen and to explore themes that might become fully-fledged as paintings. Romney, like Gainsborough, repeated certain subjects on paper tens and sometimes hundreds of times, working them out in emotional out-bursts of pencil, black chalk and ink.[10] Whereas Gainsborough chose wooded landscapes and peasant figures, Romney favoured literary themes. Both artists returned repeatedly to the same selected ideas over long periods of time. For some subjects, such as the *Cottage Door*, Gainsborough produced not one, but a series of paintings; other ideas remained on paper and were never fully realised.[11] Repetition did not have the same negative connotations then as now. In portraiture painters commonly repeated poses: the attitude of *Anne Ford* (fig. 2), for example, which dates from 1760, is used again with only minor changes in *The Hon. Mrs Watson* (fig. 3) of 1786, and there are a good many other variations in between.[12] In addi-tion, clients sometimes ordered more than one version of a particular portrait, one for themselves and others for friends or relatives. Gainsborough and his contem-poraries charged the same price for the first and any subsequent copies of such portraits.

Gainsborough's approach to composition can be determined from what he had to say on the subject in his letters, from what his contemporaries observed of his working practice, and from the evidence of the works themselves. The letters are vividly written and often frank to the point of being blunt. One, in particular, from the 1760s, shows that he was not willing to compromise on composition, even in the face of a request from a wealthy patron. Lord Hardwicke had asked Gainsborough to paint a particular view, perhaps a scene on his estate. The artist sent his regrets, explaining that 'with regard to real Views from Nature in this Country, he has never seen any Place that affords a Subject equal to the poorest imitations of Gaspar or Claude', adding that 'if His Lordship wishes to have any thing tollerable of the name of G. the Subject altogether, as well as figures etc must be of his own Brain…'.[13] The typical landscape of Gaspard Dughet (1615–1675) and Claude Lorrain (1600–1682) features scenery based on the terrain of the Roman Campagna with a few buildings, a road or river snaking away into the distance, and elegant trees in the foreground to frame the view. Gaspard Dughet's landscape tends to be the more rugged and wooded, and Claude's the most likely to be bathed in a golden

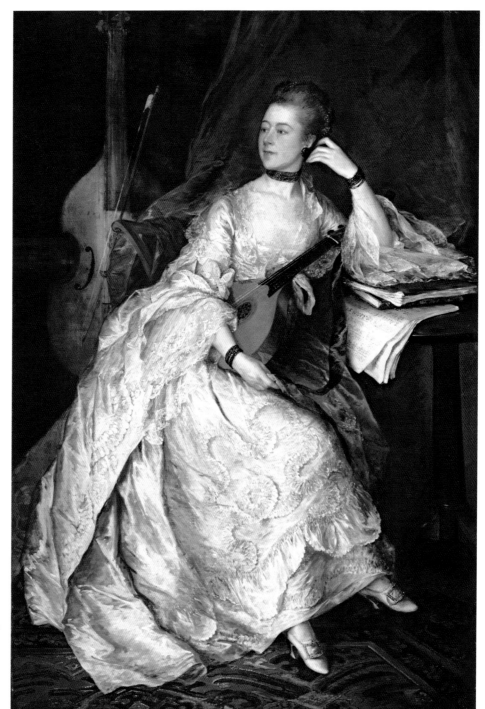

Fig.2 *Ann Ford, later Mrs
Philip Thicknesse*, 1760
Oil on canvas, 196.9 x 134.6 cm
Cincinnati Art Museum,
bequest of Mary M. Emery.
1927.396

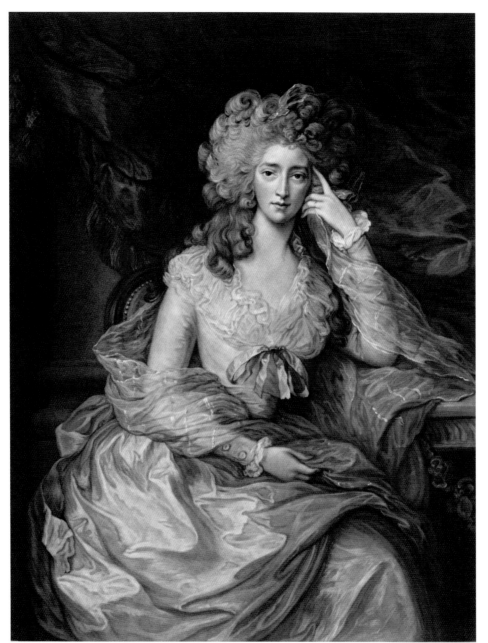

Fig.3 Thomas Park (b.*c.*1750)
after Thomas Gainsborough
The Hon. Mrs Watson
Mezzotint, 50.5 x 35.4 cm
(trimmed) after a painting
of 1786
British Museum, London.
1902,1011.3573
© The Trustees of the British
Museum

evening light. Before Gainsborough favoured this sort of ideal landscape he did occasionally paint 'real views' and had turned to Netherlandish models for inspiration. These earliest paintings he recalled fondly as 'my first imatations of little Dutch Landskips'.[14]

For Gainsborough and most other British painters of the period, the works of admired Continental artists set a standard, but imitation alone did not make for success. Some knowledge of the theory of art was desirable, even for such a non-academic painter as Gainsborough. His own highly idiosyncratic manner of explaining the principles of composition is preserved for us in correspondence with his friend the musician and amateur artist William Jackson (1730–1803). As Gainsborough saw it, the selective grouping of objects 'in friendship' was fundamental, and he uses the analogy of music to make his point:

> The lugging in Objects whether agreeable to the whole or not is a sign of the least Genius of any thing, for a person able to collect in the Mind, will certainly groupe in the Mind also; and if he cannot master a number of Objects, so as to introduce them in friendship, let him do but a few – and that you know my Boy makes Simplicity – one part of a Picture ought to be like the first part of a Tune … that you can guess what follows, and that makes the second part of the Tune, and so I've done—.[15]

As to how Gainsborough himself set about the process of designing a painting, we have more than one account of his habit of building three-dimensional model landscapes. The use of small models as an aid to composition was relatively common on the Continent. They looked something like miniature stage sets, and were employed by artists as diverse as Caravaggio, Poussin and Boucher. Some models were arranged within enclosed boxes and included wax figures and architectural elements, the scenes being illuminated through slits in the sides. The most elaborate were designed to help with problems of perspective and are described in theoretical texts that circulated widely during the eighteenth century.[16] There is little evidence of the practice in England except for someone's remark, possibly meant as a joke, that Richard Wilson 'painted his rocks from a fractured mass of old Cheshire cheese'.[17] One of Gainsborough's acquaintances reported that he had 'more than once sat by [Gainsborough] of an evening, and seen him make models, or rather thoughts, for landscape scenery, on a little old-fashioned folding oak table'.[18] This table, the writer added, was kept under the kitchen dresser, and the artist would have it sent up to his parlour where he used cork or coal to make

foreground rocks, sand and clay for the middle ground, lichens and mosses to make bushes and broccoli for distant woods. By correcting himself and calling these constructions 'thoughts' rather than models, and by saying that they were made in the parlour, the author sheds light on their purpose. They were not made so that Gainsborough could sit or stand at an easel in his painting room and copy them, but were a means of stimulating ideas. They were, in essence, three-dimensional imaginative drawings.

Broccoli and herbs must have wilted overnight but, happily for us, drawings on paper are more robust. William Jackson guessed that he had seen about a thousand of Gainsborough's drawings, and today well over a thousand are recorded.[19] These were probably an even more important part of the creative process than the models. Over time many have changed in appearance through the darkening of varnish, the discolouring of white paper, the fading of coloured paper from blue to brown and the fading of watercolour, but it is still possible to appreciate the workings of the artist's imagination through these drawings. Some of them are in themselves extraordinary works of art. It is in Gainsborough's drawings that he can be seen organising shapes, emphasising this or that part of the composition, creating broad masses of shadow and pools of brightness and, sometimes, changing his mind. At all stages of his career Gainsborough drew in a variety of media and on different papers, but in general pencil drawings are limited to the early years and varnishing is found on drawings from the late Bath period onwards, but not at an earlier date. The artist's daughter said that 'he scarcely ever in the advanced part of his life drew with black lead pencil as He cd. not with sufficient expedition make out his effects.'[20] It was then that he turned to black and white and coloured chalks, watercolour and ink washes. On occasion he used small pieces of sponge held by sugar tongs or tied to sticks to apply the watercolour or diluted ink.[21] Although he drew at speed, he took great pains with his technique. Two letters to the printer and publisher James Dodsley show him endeavouring to obtain the same wove paper on which he observed Dodsley had printed the popular collection of epistolary poems *The New Bath Guide*, written by Christopher Anstey. Gainsborough had looked closely at this book (in which there is a humorous reference to his sister, a well-known Bath milliner), and noted that the paper had less of a glaze on it than Dodsley's writing paper and would be almost as good for drawing as old Italian drawing paper.[22] The correct use of materials was as important as the choice of paper. In 1773 he sent a detailed instruction to Jackson on the procedure for

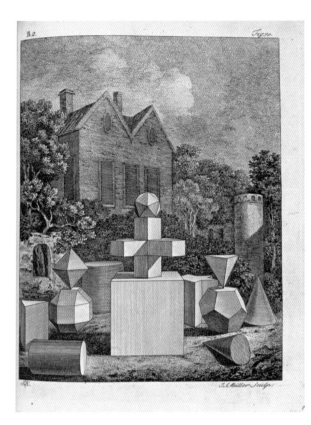

1. Joshua Kirby, *A Variety of Figures …[containing] all the Rules and Principles of Perspective* © The Royal Academy of Arts, London; photographer Prudence Cuming Associates

making a mixed-media drawing. He advises first laying in the ground work in Indian ink and putting in white chalk highlights. The sheet was then to be dipped in skimmed milk to fix the chalk. Then, while it was still wet, the paper was glued to a specially made wooden frame (like a canvas stretcher) and dried before more effects were made out in ink wash. Watercolours could then be added and when these were dry, the whole floated over with a Gum Arabic solution. To finish, the drawing was to be varnished three times with spirit varnish, not forgetting to varnish the back as well so that the paper did not curl. The varnish for this purpose was probably developed by or with the help of one of Gainsborough's neighbours in the Circus at Bath, an amateur chemist and art lover by name of Benjamin Colborne (d. 1793).[23] It is clear from his instruction to Jackson that Gainsborough was prepared to go to great lengths to create his desired effect.

The drawings that were made in this and a variety of other ways were not sold, but Gainsborough did give many away. Some are marked with a stamped monogram 'TG' (no. 17), or a stamp of the whole name 'Gainsborough', which suggests that these were made as gifts.[24] They were much admired by fellow artists. The antiquary and artist John Thomas Smith (1766–1833) who became Keeper of prints and drawings at the British Museum, thought the drawings of Richard Wilson, 'valuable and truly epic' but still found them inferior to Gainsborough's.[25] John Hoppner (1758–1810), the portrait painter, was 'passionately enamoured' of Gainsborough's drawings and made a reasonable attempt at copying his style.[26] At the studio sale after Gainsborough's death a hundred and forty eight drawings were on show, and by the time one newspaper reviewer got to see them, over a third had sold. The critic described them as 'beautiful sketches; expressive at once of the genius and powerful touch of this great master: they improve on the eye as it views and reviews…'.[27] At Christie's in 1799 Gainsborough's sketchbooks sold for higher than expected prices.[28] The artist's

printmaking experiments in the 1770s suggest that he planned to make a series of etchings in imitation of drawings, presumably with the intention of satisfying would-be collectors (no. 4). Some of these etchings were, at an early date, trimmed and mounted within wash-lines like drawings.[29] In the 1790s the connoisseur and amateur artist Dr Thomas Monro owned over 130 drawings by Gainsborough as well as the artist's landscape transparencies and their candlelight viewing-box. The doctor entertained dinner guests with the transparencies and invited young painters to his regular evening 'academy' where the drawings were laid out for copying: his house at this time was dubbed 'Gainsborough Hall'.[30] Among those young copyists were some of the greatest artistic names of the next generation, including Girtin and Turner.

During his lifetime Gainsborough's drawings were known to an inner circle of friends, artists and connoisseurs, but not to the wider public. His landscape oil paintings were regularly shown at the Society of Artists and Royal Academy annual exhibitions, and were exhibited at the artist's own houses in Bath and London. Individual responses to them were mixed. One visitor to Gainsborough's house in the Circus, Bath, in 1770, saw portraits and landscapes and considered that the artist excelled most in landscape.[31] In Schomberg House, Gainsborough's London residence, landscapes hung in the corridor leading to the painting room as well as in subsidiary showrooms. Henry William Beechey, son of the portrait painter Sir William Beechey, says that some clients swept past the landscapes, scarcely noticing them.[32] In general, though, these paintings seem to have been greatly admired. A journalist writing about the 1781 Royal Academy show, which included the oval *River Landscape with a Bridge* (fig. 6) said 'Mr. Gainsborough is confessedly the principal support of the present exhibition. The critic eye alternatively wanders from his portraits to his landscapes, and becomes too much enraptured with either to decide which are the most entitled to pre-eminence.'[33] Shortly after Gainsborough's death the *Morning Post*

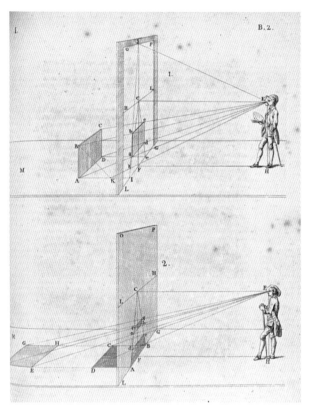

Fig.4 Here attributed to Thomas Gainsborough and Joshua Kirby (1716–1774) *Dr Brook Taylor's Method Made Easy*, Ipswich 1754, Book II, Plate B2, opposite p.8 Engraving, 25.4 x 19.7 cm (page size)
Royal Academy of Arts. 03/2826
© The Royal Academy of Arts, London; photographer Prudence Cuming Associates

reported that 'the slightest sketch' by Gainsborough was of great value and one John Burton 'was engaged to make copies of many efforts of Gainsborough's beautiful and simple taste'.[34]

English landscape art, which had been so little appreciated in the first quarter of the century, was now being taken seriously. The improved state of English painting as a whole owed a good deal to the long-lasting influence of the painter and writer Jonathan Richardson (1665–1745). Richardson himself was a portraitist, but he wrote for painters of all forms of pictures and, just as importantly, for collectors. He personally owned a famous collection of Old Master drawings and his essays are as instructive on the subject of drawing as on painting. Drawings by the great masters are, as Richardson put it, 'exceedingly prized by all who understand, and can see their beauty; for they are the very quintessence of the art'.[35] For the connoisseur, a drawing reveals the personal voice, or handwriting of the artist. The more we look, the more we understand. By the 1790s, Dr Monro's copyists and many collectors were seeing in Gainsborough's drawings the quintessence of his art. Like these early viewers, we can learn to read the handwriting and see, for example, that the clusters of white blobs or loops of white chalk in certain landscapes are sheep. They may be quite out of scale, and without detail, but compositionally these white accents are important. In one drawing they join together like a necklace to form an arc around a pond beneath towering rocks (no. 35). The fact that they are sheep scarcely matters. Richardson observed that 'first sketches not being intended to express more than general ideas, any incorrectness in the figures or perspective, or the like, are not to be esteemed as faults … the sketch, notwithstanding such seeming faults, may shew a noble thought, and be executed with great spirit, which was all that was pretended to …'.[36]

Gainsborough's letter to Jackson on 'grouping in the Mind' in order to place objects 'in friendship' says much the same thing as Richardson on composition. Using an analogy that was believed to date back to Titian, Richardson wrote,

> Pictures should be like bunches of grapes, but they must not resemble a great many single grapes scattered on a table; there must not be many little parts of an equal strength, and detached from one another, which is as odious to the eye as it is to hear many people talking at once. Nothing must start, or be too strong for the place it is; as in a concert of musick when a note is too high, or an instrument out of tune; but a sweet harmony and repose must result from all the parts judiciously put together, and united with each other.[37]

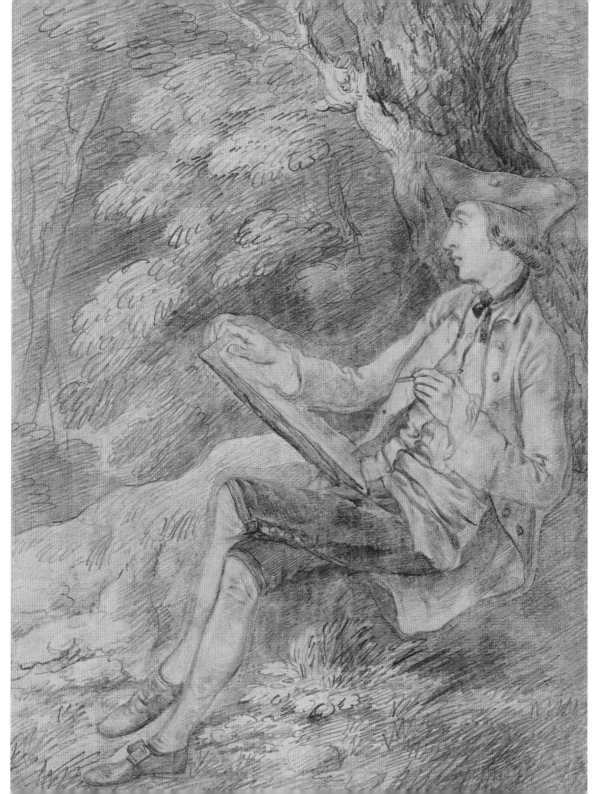

It is pertinent that Richardson also drew a parallel between pictorial composition and musical composition. For Richardson and Gainsborough, the harmony of the composition as a whole is what ensures that a picture has a presence across a room. Richardson notes that in a figure subject or still life the area of strongest light should be near, but not exactly at the centre of the picture and for a landscape there should be a mass of dark at the bottom, a light layer above that and the brightest patch of all still higher up.[38] One eighteenth-century commentator provides an amusing account of an aspiring connoisseur standing back and 'pushing his spectacles upon his forehead' to examine a landscape painting, 'making a peep-hole of his half-closed fist … to take in the whole effect'.[39]

Jonathan Richardson's essays were familiar to all self-respecting English artists of the eighteenth century, and there is plenty of evidence that Gainsborough had read them.[40] On the subject of composition, in particular, he took Richardson to heart. As an example of good composition that modern painters would do well to examine, Richardson cites Rubens's *Descent from the Cross*.[41] He analyses Rubens's use of light in the *Descent* and, mindful of the fact that not all his readers would be able to see the original painting in Antwerp Cathedral, advises them to refer to the engraving after it by Lucas Vorsterman (1595–1675). Gainsborough followed Richardson's advice to the letter, painting in oils a copy of the *Descent from the Cross*, using Vorsterman's print as his guide.[42] A desire to see this painting may have prompted his one and only trip abroad, which was to Antwerp, in 1783.[43]

Gainsborough was too young to have known Richardson personally, but he was close to another theorist, Joshua Kirby (1716–1774), an artist, architect and author of a treatise on perspective, *Dr. Brook Taylor's Method of Perspective made Easy*, published in Ipswich (then Gainsborough's home town) in 1754 (no. 1).[44] Kirby was an early mentor to Gainsborough and the two men remained friends until Kirby's death. The depth of their attachment can be judged from the fact that Gainsborough asked to be buried beside Kirby at Kew, in the graveyard of St. Anne's church, a building that Kirby had remodelled in 1770.[45] (Not for Gainsborough the grandeur of St. Paul's, where Reynolds was to be buried in 1792.) Gainsborough's loyalty to Kirby is touching, and it is worth asking what effect Kirby had on his art. The experience of Kirby's daughter Sarah, later Sarah Trimmer, a pioneering educationalist, shows that Kirby possessed an infectious enthusiasm for nature. It was said that Sarah 'had early been taught by her father to make observations on the works of creation; and had such pleasure in doing this, that to her the mere view

of the vegetable or animal world, of the clear expanse of heaven, or the smooth surface of water, was ecstacy and rapture'.[46] When compiling his treatise Kirby probably mulled over his thoughts with Gainsborough, since a strong mutual respect had obviously been established by the early 1750s, despite Gainsborough's relative youth. The book includes a plate that he calls 'a variety of Figures tending to various vanishing Points ... amongst which are the five regular Solids; and the whole together, contains all the Rules and Principles of Perspective' (no. 1). He places these geometric forms in a landscape, showing how, by correct drawing, they acquire weight and depth and occupy space. The whole illustration looks rather like a stage set inhabited by abstract shapes. Another of Kirby's plates is a straightforward print of a landscape by Gainsborough who is described in the text as 'a very great Genius in that Way'.[47] A further diagrammatic plate shows the sight lines of an artist, who appears twice, as a young man standing with a palette (fig. 4). It is suggested here that this figure was drawn by Gainsborough. It even looks rather like a self-portrait, although it is hard to imagine Gainsborough taking such a studious interest in imaginary sight lines. The reference to Gainsborough's 'genius' in landscape seems to be the earliest such instance in print and would have been noticed with interest by a number of eminent painters who subscribed to Kirby's book, including Nathaniel Hone, Thomas Hudson, George Knapton and the veteran of landscape painting, George Lambert. Kirby's reduction of the elements of a picture to essential shapes may have informed some of Gainsborough's drawings in which natural forms are described in a sort of near-geometric shorthand (no. 8). Kirby's knowledge of perspective is gleaned from a number of earlier texts, and it is most likely that he had read about the use of models as drawing aids and passed this information to Gainsborough.[48] Most importantly, Kirby's sense of awe in the presence of nature can only have encouraged Gainsborough's practice of drawing outdoors.

Drawing from nature was a particular skill of Netherlandish seventeenth-century artists. Adriaen van de Velde (1636–1672) for example, made a habit of going once a week into the countryside to draw, although his compositional sketches were entirely from imagination. When he was ready to paint, having worked out the overall form of his picture, Van de Velde turned to his stock drawings of figures, animals and other details to flesh out the composition.[49] For practical reasons, drawing outdoors generally involved simple materials such as pencil or chalk and a sketchbook. In his *Self-Portrait* drawing (no. 2) now in the British Museum, Gainsborough shows himself holding a stick of graphite or chalk in a port-crayon

as he sketches in the open air. He is in a wood, seated on a grassy bank, the tails of his coat providing protection from the damp. The likelihood is that the figure was actually observed indoors in front of a mirror (the left hand is shown drawing). It was then cut out and laid onto another sheet of paper on which the landscape is drawn. The cutting-out may have occurred because he was unhappy with his first attempt at the background, or because the paper became damaged or soiled. Even though this *Self-Portrait* is a deceit in this respect, Gainsborough certainly drew from nature, especially during the formative years of the 1740s and '50s. He is unlikely ever to have used oils outdoors. Such a practice was still uncommon in the mid-eighteenth century, although later on Sir Joshua Reynolds advised the marine artist Nicholas Pocock, 'carry your palette and pencils [brushes] to the water side.' Reynolds had seen in Rome Claude-Joseph Vernet's on-the-spot oil sketches, and was struck by their veracity.[50] Gainsborough, who sought a different kind of truth, did not care to use his palette anywhere other than his own painting room.[51]

The three essential processes of drawing from nature, absorbing the influence of earlier artists, and using the imagination to create a composition, can be traced through the example of a bridge, a subject that recurs in Gainsborough's work. A sketchbook 'from life' study that probably dates from the early 1750s is now in the British Museum (no. 3). In around 1759, the year in which he settled in Bath, Gainsborough made a highly finished drawing that features a bridge or bridge-like form (fig. 5). Crucially, in this drawing, which is a work of imagination, the bridge is coupled with a ruined building. On almost every occasion thereafter when Gainsborough constructed a composition round a bridge, he included a ruin beside or behind it. Sometimes the ruin looks like a castle, at others it resembles an ecclesiastical building. The most notable work on this theme is the oval *River Landscape* now in Japan (fig. 6), the oil that attracted much favourable attention at the Academy in 1781. One newspaper critic who saw the picture at that time had evidently read Richardson. He commented,

> In viewing this picture from the opposite side of the room, nothing can equal it. It is in a broad masterly style; and the principal light being in the centre, upon the white cow, is extremely well contrived; the other lights are kept down, and made subservient to it; the figures are well grouped, and the lines happily contrasted.[52]

The style of bridge and building changes from one drawing to another and, in a limpid wash study of the last decade that belongs to the Ashmolean Museum, the

bridge has shrunk dramatically, while the castle looms large in the centre back-
ground (no. 5). Another late drawing now in Atlanta (fig. 7) has the ruin topped by
a broken arch that curves up like a great question mark. Though dating from so
many years later, the form of this ruin is very like that in the drawing of 1759
(fig. 5). A soft-ground etching that probably predates the oval oil painting, and is
similar in composition, shows Gainsborough having second thoughts about the
number of arches in its bridge, one impression having three and others four arches
(no. 4). A possible fifth arch can even be seen lightly laid in beneath the small tree
in the four-arch version of the composition. This etching appears to be one of those
made by the artist himself to create marketable works on paper. As is the case with
other etched designs, only a handful of early impressions are now known, and no
proper edition was issued in Gainsborough's lifetime.[53] In the mid-1780s he
returned to the composition of the oval oil and the etching, this time reducing the
size of the ruin and setting the bridge further back in space (fig. 8).

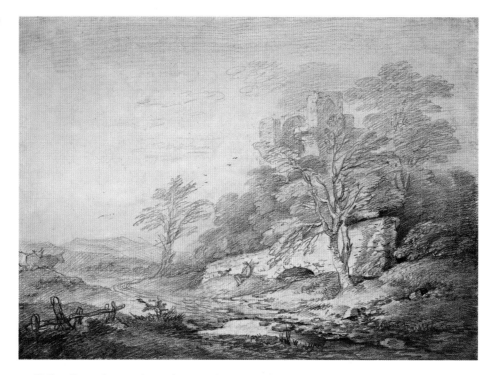

Fig.5 *Landscape with a Bridge and ruined Castle, c.*1759
Pencil, 25.9 x 35.9 cm
Private collection c/o Lowell
Libson Ltd

Why Gainsborough so frequently associated a bridge with an ancient building is unknown, but similar combinations occur quite frequently in the work of the Dutch Italianate painters. Bridges sometimes had a symbolic significance. The most famous ancient bridge to appear in the paintings of Claude and his contemporaries is the Ponte Molle, or Milvian Bridge near Rome. This was a useful eye-catching feature in paintings of the Roman Campagna, and it was also a potent Christian symbol. It was at the battle of Milvian Bridge in 312 AD that the first Christian emperor, Constantine I, triumphed over his rival Maxentius, guided, or so it was believed, by a vision of the cross of Christ. For Gainsborough the primary function of the bridge is to serve as a compositional anchor around which the different surfaces and colours of stone, foliage and water are brought together. Bridges also provide a channel for animals and figures that bring human interest, scale and movement into a landscape. The bridges and ruins may be compared with the romantic rustic features that country estate owners were busily installing in their gardens at this date, and it can be shown that Gainsborough's ideal countryside had an

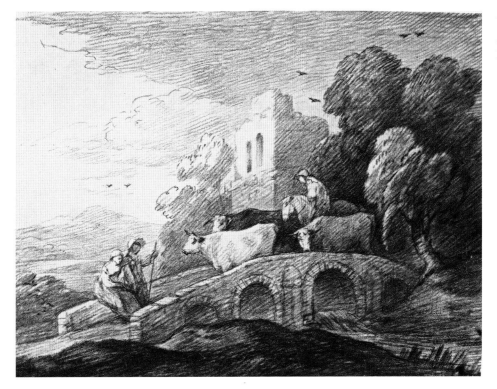

influence on the development of the Picturesque landscape garden as conceived by Uvedale Price and Richard Payne Knight (see also pp. 71–73).

It is not unreasonable to detect an allegorical meaning in some of Gainsborough's landscapes and eighteenth-century viewers would have been open to interpreting the pictures in this way. John Constable believed (presumably because someone had told him so) that Jacob van Ruisdael's famous *Jewish Cemetery* was an allegory of the life of man: 'there are ruins to indicate old age, a stream to signify the course of life, and rocks and precipices to shadow forth its dangers'.[54] The manner in which Gainsborough spoke and wrote shows that he was an ingenious creator of multi-layered concepts. His conversation was said to have been full of flashes of brilliance and humour. In his correspondence he uses elaborate metaphors and plays with words. In the same letter to Jackson that advises on composition he thanks the musician for a present of some indigo pigment. 'Your Indigo' he writes, 'is cleare, like

Fig.6 *River Landscape with a Bridge and ruined Castle,* 1780–81
Oil on canvas, 122.6 x 163.2 cm
Tochigi Prefectural Museum of Fine Arts, Japan

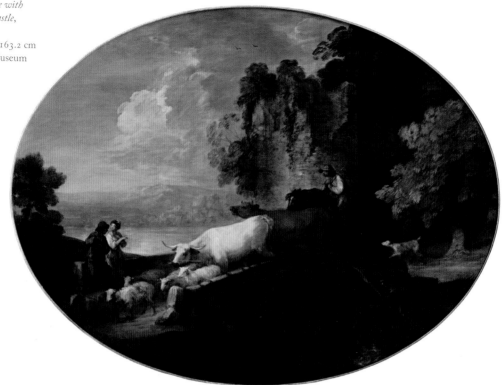

your understanding & pure as your Music, not to say exactly of the same Blue of that Heaven from whence all your Ideas are reflected …'.[55] In another letter to the same recipient Gainsborough describes his meeting with John Dunning, an eminent barrister and famous orator. Gainsborough tells Jackson that he found this man's intelligence and mode of address 'exceedingly pleasing'. He speaks of Dunning's mind 'brandishing, like Lightning, from corner to corner of the Earth … his Store-Room seems cleared of all French Ornaments and gingerbread Work, every thing is simplicity and Elegance in its proper place; no disorder or confusion in the <u>furniture</u> as if he was going to remove'.[56] Such figures of speech suggest that when we consider Gainsborough's imaginative work we should always be prepared to look beyond first appearances.

The headings used for each of our six themes are taken from Gainsborough's letters. Some of these headings are descriptive, such as 'the mild Evening gleam';

(opposite)
5. *Landscape with Cattle and Castle Ruin,* 1785–88
Reproduced courtesy of the Ashmolean Museum, Oxford

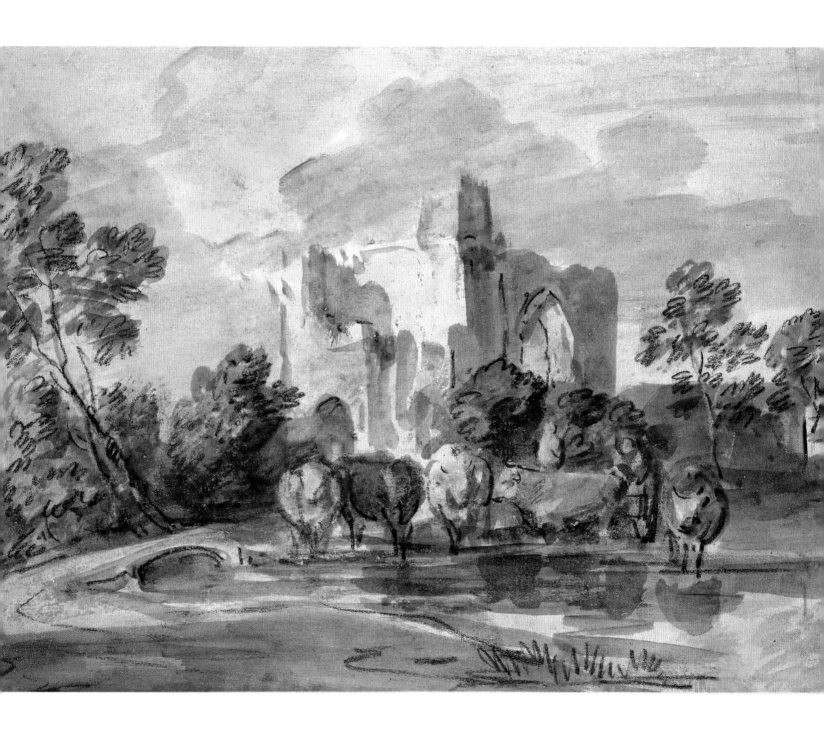

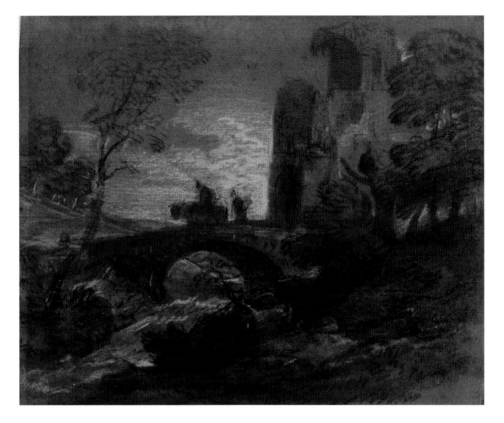

others hint at the meaning of the subject. George Romney rehearsed particular subjects and motifs until they began to evolve into different ones, and Gainsborough sometimes did the same.[57] The *Watering Place* (no. 20) evolves into the composition of the Royal Academy *Romantic Landscape* (no. 30), although, as certain drawings demonstrate, the *Watering Place* composition itself is never entirely abandoned. As to what is achieved by the mastery of composition, or 'grouping in the mind' as Gainsborough called it, Jonathan Richardson expresses it boldly when he says that 'the great and chief ends of painting are to raise and improve nature'.[58] In all his writings, Richardson's objective was to demonstrate that painting was a liberal and not a 'mechanical' art, and thereby to elevate the status of painters in Britain in his own time. Landscape painting was traditionally considered the lowliest of the imaginative branches of painting and less capable of conveying noble thoughts than

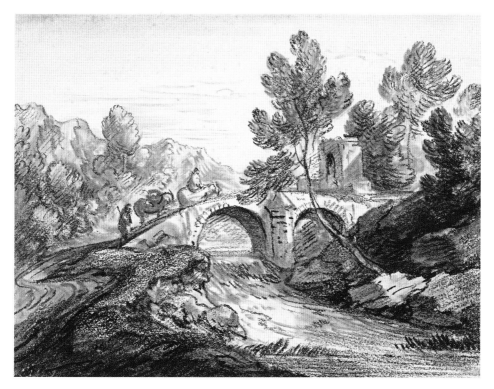

history painting, but in the hands of Richard Wilson and Gainsborough the art was indeed 'rescued' as Constable recognised in his lecture 'The Decline and Revival of Landscape'. Neither Wilson nor Gainsborough treated landscape as a purely imitative or representational art. Wilson was inspired by his travels in Italy to create his own form of classicism, and Gainsborough, who ventured no further than Antwerp, turned the scenery around him into an ideal landscape that remains distinctively English.

NOTES

The key to abbreviated references is to be found in the Bibliography on pp. 109–10.

1 R.B. Beckett, (ed.), 'John Constable's Discourses', *Suffolk Records Society*, XIV, 1970, Lecture IV, p. 67, from 'The Decline and Revival of Landscape' delivered at the Royal Institution, Albemarle Street, 16 June 1836.

2 Rosenthal and Myrone 2002; Bermingham 2005.

3 Hayes 2001, no. 104, pp. 168–69, to Henry Bate, 11 March 1788.

4 The title *Thomas Gainsborough, Themes and Variations: The Art of Landscape* was used for a commercial exhibition of seven works by Gainsborough presented by Lowell Libson at W.M. Brady & Co., New York in 2003. An exhibition *Richard Wilson: Themes and Variations*, was held at the Glynn Vivian Art Gallery, Swansea, in 1999, accompanied by a catalogue of the same name with short essays by Robin Simon, Kilian Anheuser and Yoko Kawaguchi.

5 The nature of the fancy picture is discussed in the context of the third and fifth of our six themes, see pp. 49, 53–54, 77–87.

6 Kidson 2002, under no. 10, p. 53.

7 Joseph Wright, 'Account Book', National Portrait Gallery, MS 111, fol. 51.

8 Hayes 1982, I, p. 1, quoting the artist Nicholas Vleughels (1668–1737), director of the French Academy in Rome.

9 Philip Thicknesse, *A Sketch of the Life and Paintings of Thomas Gainsborough, Esq.*, London 1788, pp. 5–6.

10 According to Deanna Petherbridge, *The Primacy of Drawing: Histories and Theories of Practice*, New Haven and London 2010, p. 35, Romney drew *Howard visiting a Prison* 500 times.

11 Bermingham 2005.

12 Waterhouse 1966, no. 660, p. 92; no. 714, p. 95. The mezzotint is used here to illustrate Mrs Watson's portrait as the original painting is now not in good condition.

13 Hayes 2001, no. 15, p. 30, to Philip, Second Earl of Hardwicke, not dated, but after 1764.

14 Hayes 2001, no. 108, to Thomas Harvey, 22 May 1788.

15 Hayes 2001, no. 42, p. 71, to William Jackson, undated but probably February 1770.

16 See Oskar Bätschmann, *Nicolas Poussin: The Dialectics of Painting*, London 1990, pp. 27–29.

17 Hayes 1982, I, note 70, p. 158.

18 Notice attributed to 'An Amateur of Painting', *Somerset House Gazette*, I, 1824, p. 348. According to Hayes 1982, I, p. 301, the author is William Henry Pyne (1769–1843). Reynolds mentions Gainsborough's table-top models: see Sir Joshua Reynolds, *Discourses on Art*, ed. Robert R. Wark, San Marino 1959, p. 250.

The description in Edwards 1808, p. 135 appears to be based on Reynolds, and, being in the form of a footnote, was probably added after the author's death (the artist Edward Edwards died in 1806 and his book was edited and published posthumously).

19 Following Hayes's catalogue of 1970 the same author catalogued newly-discovered drawings in the journal *Master Drawings* (Hayes 1983), bringing the number up to 987. Hugh Belsey's 'Second Supplement to John Hayes's The Drawings of Thomas Gainsborough' in the same journal (Belsey 2008) brings the catalogue to 1,121, but Belsey notes that in one or two cases Hayes accidentally catalogued the same drawing twice.

20 Farington 1978–98, IV, p. 1149, entry for 29 January 1799.

21 Angelo 1969, I, pp. 168–69; Edwards 1808, p. 139.

22 Hayes 2001, no. 25, pp. 44–45 to James Dodsley, 10 November 1767; no. 26, pp. 45–46, to James Dodsley, 26 November 1767. Christopher Anstey's *New Bath Guide* was first published in 1766 and quickly ran to several editions.

23 Sloman 2002, pp. 111–12.

24 Mrs Gainsborough reported that her husband had made it a rule never to accept money for drawings, see Whitley 1915, p. 315. Edwards 1808, p. 142 notes that the stamps Gainsborough used were bookbinders' tools.

25 John Thomas Smith, *A Book for a Rainy Day*, second edition, London 1845, pp. 262–63.

26 Farington 1978–98, VI, p. 2147, entry for 21 October 1803.

27 *The Diary, or Woodfall's Register*, issue 4, 2 April 1789, p. 3.

28 Farington 1978–98, IV, p. 1222, entry for 11 May 1799.

29 See Hugh Belsey, 'Two prints by Gainsborough', *Gainsborough's House Society Annual Report 1989/90*, 1990, fig. 13, p. 43.

30 Morris and Milner 1985, under no. 88, p. 95.

31 Hugh Belsey, 'A visit to the studios of Gainsborough and Hoare', *Burlington Magazine*, CXXIX, no. 1007, February 1987, pp. 108–09.

32 Henry William Beechey, 'Memoir of Sir Joshua Reynolds' in Joshua Reynolds, *The Literary Works of Sir Joshua Reynolds*, 2 vols., London 1846, I, p. 170. Hayes, following Fulcher, mistakenly attributes the commentary to Sir William Beechey.

33 *Whitehall Evening Post*, issue 5469, 1–3 May 1781, p. 2.

34 Whitley 1915, p. 316. Whitley considers John Burton, an actor and amateur exhibitor at the Royal Academy, was copying drawings, presumably because of the reference to the 'pencil of the late Gainsborough' but in eighteenth-century parlance a 'hair pencil' is a paintbrush (hence pencilling) and a 'lead pencil' a stick of graphite held in a port-crayon or a wooden casing. G.F. Phillips, *A Practical Treatise on Drawing, and in Painting in Water Colours*, London 1839, still refers to a brush as a pencil.

35 Richardson 1773, p. 82, from 'The Theory of Painting', an essay

first published in 1715.

36 Richardson 1773, p. 83.

37 Richardson 1773, p. 69; Carol Gibson-Wood, *Jonathan Richardson, Art Theorist of the English Enlightenment*, New Haven and London 2000, p. 164 and note 20, p. 249.

38 Richardson 1773, pp. 65, p. 68.

39 Angelo 1969, I, p. 117.

40 Sloman 2002, p. 160.

41 Richardson 1773, pp. 65, 70.

42 Waterhouse 1966, no. 1027, p. 125. Gainsborough's copy is, like Vorsterman's print, in reverse.

43 Amal Asfour, Paul Williamson and Gertrude Jackson, 'A Second Sentimental Journey: Gainsborough Abroad', *Apollo*, CXLVI, August 1997, pp. 27–30.

44 Joshua Kirby is often mistakenly called John Joshua Kirby. John Kirby was Joshua's father.

45 The church as redesigned by Kirby is shown in David Blomfield, *Kew Past*, London 1994, fig.61, p. 54. For Kirby at Kew see David Watkin, *The Architect King: George III and the Culture of the Enlightenment*, London 2004, pp. 61–65; for Kirby's publications see Eileen Harris and Nicholas Savage, *British Architectural Books and Writers 1556–1785*, Cambridge 1990, pp. 254–58.

46 [Sarah Trimmer], *Some Account of the Life and Writings of Mrs Trimmer, with original Letters, and Meditations and Prayers, selected from her Journal*, 2 vols., London 1814, I, p. 39.

47 Kirby 1754, Book II, p. 58.

48 Bätschmann (see note 16 above) names relevant texts by Joachim von Sandrart, Roger de Piles and others.

49 Peter Schatborn and William W. Robinson, *Seventeenth-Century Dutch Drawings: A Selection from the Maida and George Abrams Collection*, exhibition catalogue, Rijksmuseum, Amsterdam, 1991, p. 10.

50 Ingamells and Edgcumbe 2000, no. 86, pp. 87–88, Reynolds to Nicholas Pocock, 4 May 1780. Philip Conisbee, *Claude-Joseph Vernet 1714–1789*, exhibition catalogue, Iveagh Bequest, Kenwood, London 1976 (no page numbers) discusses, in the introduction, Vernet's wider influence on British landscape painters. On painting outdoors see Brinsley Ford, (ed.), 'The Letters of Jonathan Skelton written from Rome and Tivoli in 1758', *Walpole Society*, XXXVI, 1960, pp. 26–27.

51 Gainsborough expected sitters to come to him, see for example Hayes 2001, no. 46, p. 78, to James Unwin, 10 July 1770.

52 *London Courant* (no issue number), 8 May 1781, p. 2.

53 Hayes 1971, no. 11, pp. 72–77. Doubts have been raised (verbally, by Conal Shields) as to the authenticity of certain of the prints published by Hayes. The changes of mind in this particular print would suggest that Gainsborough personally etched the plate. After the artist's death this and other plates (one or two of which may not be the work of Gainsborough himself) were acquired by J. & J. Boydell who issued a numbered set of twelve prints in 1797. The bridge subject was numbered '1' in the series.

54 Seymour Slive, *Jacob van Ruisdael, A Complete Catalogue of his Paintings, Drawings and Etchings*, New Haven and London, 2001, p. 183.

55 Hayes 2001, no. 42, p. 71, to William Jackson, undated, probably February 1770.

56 Hayes 2001, no. 40, p. 68, to William Jackson, dated 4 June, the year unknown.

57 Kidson 2002, under no. 10, p. 53.

58 Richardson 1773, p. 247, from 'The Science of a Connoisseur'.

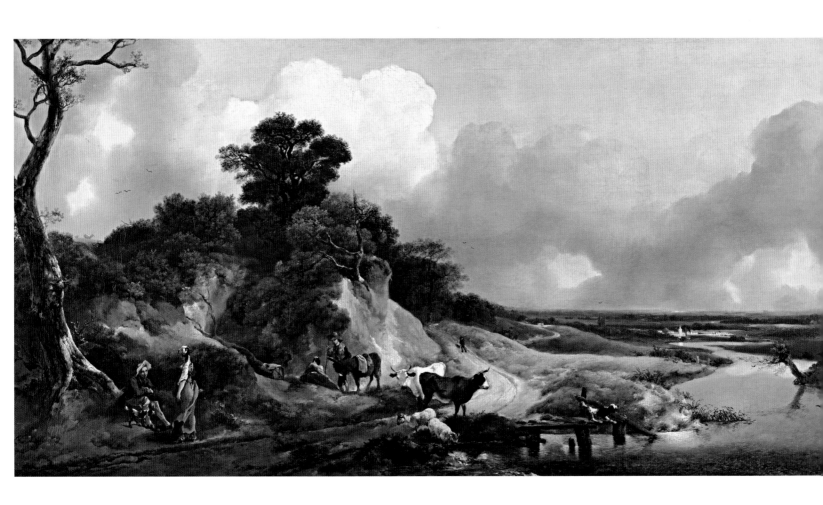

1. 'Nature is modest'

IN MAY 1766, when he was resident in Bath, Gainsborough wrote to David Garrick reporting on the annual exhibition of the Society of Artists, which he had recently viewed in London. He objected to the 'glare' of the pictures on show. 'Nature is modest', he contended, 'and the artist should be so in his addresses to her'.[1] He was alluding to a famous passage on the art of acting from Shakespeare's *Hamlet*, confident in the knowledge that Garrick, the greatest thespian of the age, would recognise the source. Hamlet's 'Speak the speech' instruction to actors urges them to 'suit the action to the word, the word to the action … that you o'erstep not the modesty of nature'.[2] Garrick introduced a new naturalism to the British stage; Gainsborough wished to do the same for painting.

At the beginning, in his early Sudbury and Ipswich landscapes, Gainsborough's choice of subject and his 'modest' manner of expression were based on the model of Dutch seventeenth-century landscape painting. In East Anglia, where he was born, and in London, where he lived between about 1740 and 1749, he was attracted to the work of Jacob van Ruisdael (1628/29–1682) and Jan Wijnants (active 1643, d. 1684).[3] His contact with Dutch pictures was sometimes so close as to be physical: he is known to have 'repaired' at least one Dutch landscape and to have added figures to a painting by Wijnants.[4] So reminiscent of Ruisdael are some of Gainsborough's own early pictures that even now works by the two painters are occasionally confused.[5] An attachment to Dutch art was by no means unique to Gainsborough, and the flatlands of Holland are not dissimilar to the landscape of parts of Suffolk, Norfolk and Essex. Another East Anglian painter, John Crome (1768–1821) is credited with the dying words 'Oh Hobbima, my dear Hobbima, how have I loved you'.[6] J.M.W. Turner, lecturing to the students of the Royal Academy in 1811, thought Gainsborough improved on the art of the Dutch by copying their best points but avoiding their defects, 'the mean vulgarisms of common life and disgusting incidents of common nature'. (By this he presumably meant the inebriated men, defecating dogs and urinating horses and cows that are found in Dutch pictures.) In Turner's opinion, 'his first efforts were in imitation of Hobbema, but English nature supplied him with better materials of study'.[7] Working in this vein Gainsborough chose to draw and paint views of heaths, sand dunes, gently wooded hills and river landscapes, the pictures that he later called 'my first imatations of little Dutch Landskips'.[8]

Gainsborough's Dutch-inspired pictures usually feature a generous expanse of sky and well-formed

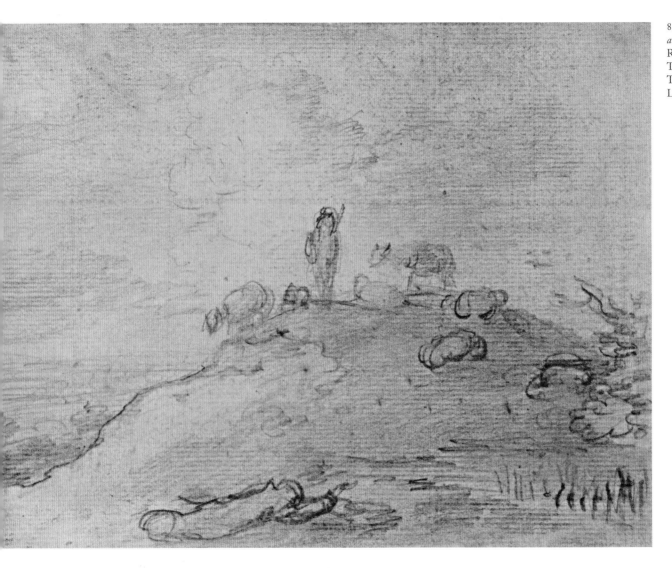

8. *Landscape with Shepherd and Sheep on a Hillock, c.*1750
Reproduced courtesy of
The Samuel Courtauld Trust,
The Courtauld Gallery,
London

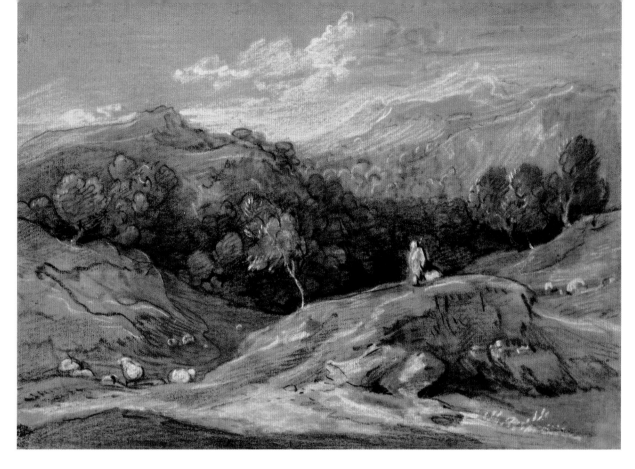

*9. Mountainous Landscape
with Shepherd and Sheep,
c.1783*
© Birmingham Museums
& Art Gallery

clouds. Often a felled or wind-broken branch lies on the ground, at an angle, containing or supporting the composition. A drawing from one of Gainsborough's East Anglian sketchbooks of the 1750s (no. 8) is startlingly abstract in construction, with a shepherd, sheep and branch reduced to the simplest of shapes, putting us in mind of Joshua Kirby's 'regular solids' in a landscape. Thirty years later, in a mountainous view drawn in black and white chalks (no. 9), we see the same shepherd standing on a very similar hillock, with sheep appearing as little more than spherical blobs in the landscape. The comparison between these two drawings is just one of many that show

the artist holding tenaciously to a favourite theme and adapting it in the light of new experience. His affection for Dutch art never waned, even at a time when he was painting large-scale fancy figures in the manner of Murillo (no. 25) and landscapes that appear to have more to do with the Italian than the north European tradition. As late as 1785 he bought a picture by Ruisdael.[9] Gainsborough's daughter reported that her father had been 'passionately fond of the pictures of Berghem & Cuyp' – that is Nicolaes Berchem (1620–1683) and Aelbert Cuyp (1620–1691).[10] Berchem and Cuyp were masters of the Dutch Italianate landscape, their idyllic vision

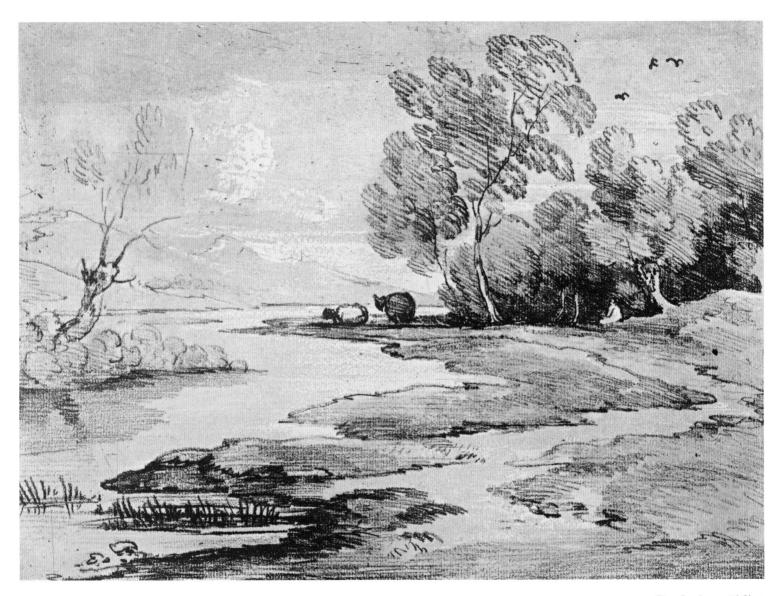

10. *River Landscape with Sheep,*
*c.*1785 © Tate, London 2011

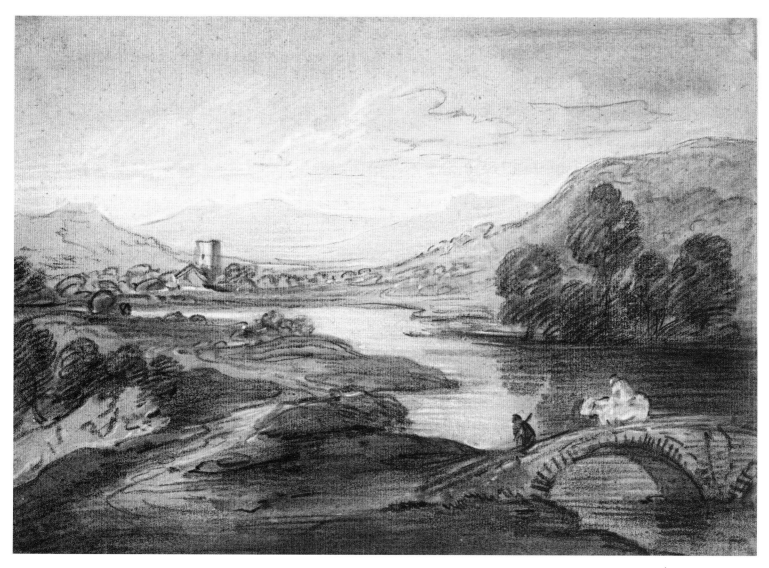

11. *Upland Landscape with
River and Horsemen crossing
a Bridge*, 1785–88
© Tate, London 2011

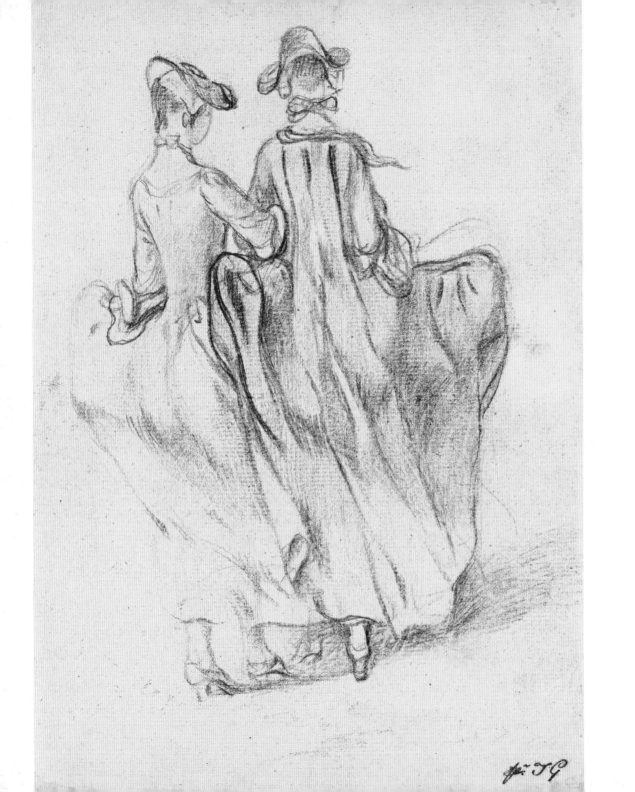

7. *Two Ladies Walking Arm-in-Arm*, 1751–52
Reproduced courtesy of the lender

(opposite detail)
6. *River Landscape with a View of a Distant Village*, c.1750
Reproduced courtesy of the National Gallery of Scotland

of the countryside being lit by a golden glow that they had learned from Claude. Berchem was an excellent figure painter and sometimes collaborated with Ruisdael, adding human interest to Ruisdael's landscapes. The motif of a pointing figure, used by Gainsborough in numerous drawings and in paintings including the *Watering Place* (no. 20) was much favoured by Berchem.

The magnificent *River Landscape* oil from Edinburgh that forms the centrepiece to this section (no. 6) is an early picture, painted around 1750, when Gainsborough was twenty-two or twenty-three years old and favoured the 'modest' style of Dutch art as exemplified by Ruisdael and Wijnants. It features a meandering river, the path of which is echoed by a road zigzagging into the distance. There are enough clouds in the sky to cast the foreground into shadow and allow a patch of bright sunlight to pool in the centre-right part of the composition, just as Richardson would have advised. The clouds are important elements in the design of the picture. At a later date Gainsborough might have faulted the composition since the figures and animals are dotted across the landscape (like Richardson's single grapes on a table) rather than grouped. The luminosity, colour and dextrous brushwork override any failings of composition, however, making it quite clear why in 1754 Joshua Kirby was already declaring Gainsborough a genius in the painting of landscape. The incidental detail is also completely beguiling, with several dialogues taking place between figures and animals. A dog barking at a bird, or perhaps something unseen on the opposite bank, is watched by a brown cow. The cow is being ignored by the milkmaid who is distracted by a young man seated at the roadside. A gust of wind catches the milkmaid's skirt, making it cling to the shapely line of her body underneath. Gainsborough, who was himself easily distracted by the charms of young women, depicted a similar effect in a seductive drawing of two smartly-dressed young ladies walking arm in arm (no. 7), and in a coastal landscape exhibited in 1781 that shows girls buying fish on a breezy seashore.[11] The drawing of two ladies dates from 1750–52, around the time of the *River Landscape*. The women wear dresses with panniers, a style that fell out of general use after this date. The drawing is a perfect illustration of the way in which Gainsborough used his pencil with sweeping strokes and varying degrees of pressure to suggest depth and indicate movement.

At the time the river scene was depicted Gainsborough was still painting the occasional 'real view' from nature. The Edinburgh picture is not of an identifiable place, but it represents the kind of scenery the artist knew from childhood. His mid-nineteenth century biographer George Williams Fulcher spoke of Gainsborough making excursions from Sudbury, drawing the 'river Stour with its green pastures, its stunted pollards and drooping willows' and then, from Ipswich, sketching the Orwell, 'its waters bearing along to the ocean the light skiff and lazy collier-boat; its banks bordered by gently rising hills…'.[12] It was when he was drawing from nature near Freston Tower on the banks of the Orwell that Gainsborough is said to have met Joshua Kirby.[13]

The meandering river that is so beautifully depicted in the Edinburgh canvas is recalled in a number of late compositions (nos. 10, 11). By this time there is no narrative, and the landscape is reduced to essential forms. The Tate drawing (no. 11) belonged to Henry Bate, the newspaper proprietor

and editor who kept Gainsborough's name in the press in the last years of his life, when he had withdrawn altogether from the Royal Academy. If, as is likely, Bate received this drawing as a gift, we can assume that Gainsborough was more than satisfied with its design. Like many late drawings, it is made with chalks. For an artist with an assured hand, chalks and coloured paper could be used to create a great variety of tones with minimal effort: the paper provides the mid-tone, the black chalk the darkest areas and the white the highlights. In this case, shades of grey were achieved with a stump, a stick made of tightly-rolled paper, felt or leather, the end of which was used to soften or blend the chalk and to apply it across the paper in a non-linear way.[14] We know that Gainsborough was a great improviser, using sugar tongs and sponge to apply ink wash when the need arose, and it is to be expected that he would have kept in his pencil box several different sized stumps, made from a range of materials. The use of stump can be seen in many other late drawings, including the study of two small girls with bundles of sticks (no. 28).

The soft-ground etching that features a winding river and path (no. 10) is printed from an unfinished plate – the pollarded willow tree being only partially drawn – but it clearly represents a design from the mid-1780s.[15] As is often the case in drawings of this date, the artist shows a complete disregard for 'true' perspective and scale. The two animals, which can only be sheep, are of elephantine proportions in relation to the figure seated at the wayside. These late landscapes are no longer representations of the scenery of East Anglia or anywhere else; they are what Timothy Clifford has called 'complex abstract constructions with great attention to rhythms, masses, voids, tones, and textures – a far cry from the Dutch realist approach of his early Suffolk days'.[16]

NOTES

1 Hayes 2001, no. 21, p. 38, to David Garrick, May 1766. Hayes publishes the letter in part, as 'untraced'. The full text is given in Marcia Epstein Allentuck, 'A Gainsborough letter to Garrick, In memoriam John Hayes', British Art Journal, no. 3, Winter 2007–08, p. 63.
2 William Shakespeare, Hamlet, Act III, scene 2.
3 For Gainsborough's first London period see David Tyler, 'Thomas Gainsborough's days in Hatton Garden', Gainsborough's House Review, 1992/93, 1993, pp. 27–32.
4 Foister 1997, p. 7.
5 Seymour Slive, Jacob van Ruisdael, A Complete Catalogue of his Paintings, Drawings and Etchings, New Haven and London, 2001, under no. 83, p. 113. A copy of Ruisdael's Grainfield beside a Road has been mistaken for a work by Gainsborough in the recent past.
6 [A.G.H. Bachrach] The Shock of Recognition, exhibition catalogue, Mauritshuis, The Hague and the Tate Gallery, London, 1971, under no. 68 (no page numbers).
7 Ibid.
8 Hayes 2001, no. 108, p. 174, to Thomas Harvey, 22 May 1788.
9 Foister 1997, p. 3.
10 Farington 1978–98, IV, p. 1149, entry for 29 January 1799.
11 Hayes 1982, II, no. 127, pp. 487–88.
12 Fulcher 1856, p. 38.
13 Ibid., p. 39.
14 Diderot's Encyclopedia illustrates a stump: this is reproduced by James Ayres in The Artist's Craft, London 1985, fig.76, p. 58. Stumps were also occasionally made of cork.
15 As to whether this etching was made by Gainsborough himself, the jury is still out (see note 53, p. 25). It certainly reproduces one of his designs.
16 Clifford 1978, p. 3.

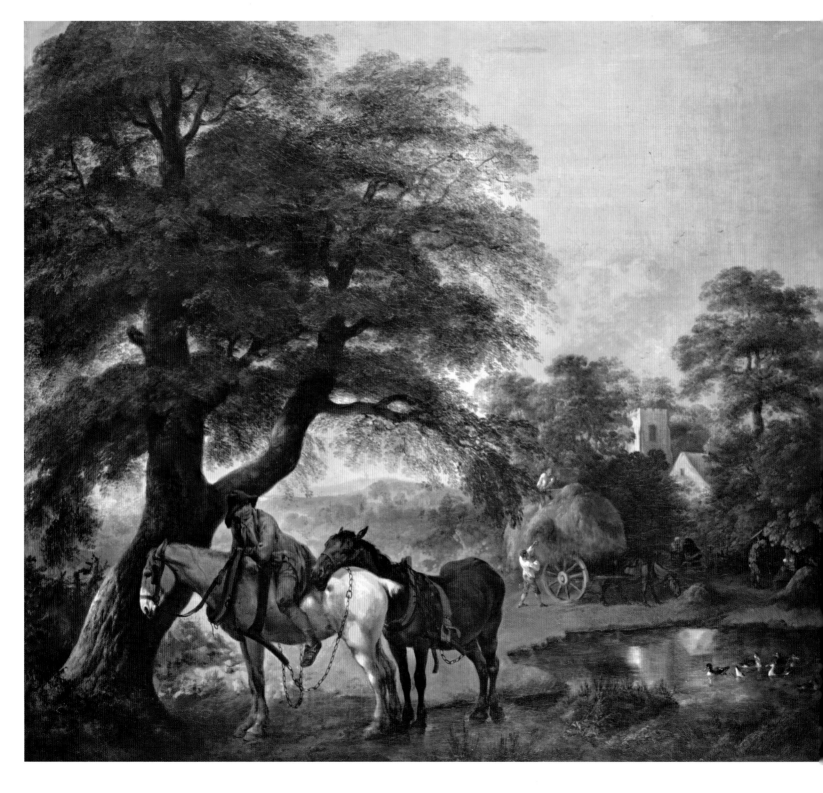

2. 'Quietness & ease'

AT THE END OF ONE OF Bath's busy social seasons in the 1760s Gainsborough wrote to his friend William Jackson professing to be 'sick of Portraits' and wishing he could take his viola da gamba off to 'some sweet Village' where he could paint landscapes and 'enjoy the fag End of Life in quietness & ease'.[1] The veteran actor James Quin, who became friendly with Gainsborough in Bath, detected two moods in the artist, 'If a portrait happened to be on the easel … he was in the humour for a congenial growl at the dispensation of all sublunary things. If, on the contrary, he was engaged in a landscape composition, then he was all gaiety – his imagination in the skies'.[2]

Portraiture was certainly exhausting work, both mentally and physically. As Gainsborough remarked to Quin, 'the perplexities of rendering something like a human resemblance, from human blocks, was a trial of patience that would have tempted holy St. Anthony to cut his own throat with his palette-knife'.[3] At the peak of his popularity in Bath, in 1770, Gainsborough reiterated 'the nature of face painting is such, that if I was not <u>already crack'd</u>, the continual hurry of one fool upon the back of another … could be enough to drive me Crazy'.[4] An effort of will was required to remain calm in the company of difficult and demanding sitters. The long days were physically draining, and for the first half of his professional life Gainsborough operated without the sort of studio assistance that most artists took for granted. Unlike Reynolds, Romney and other leading portrait painters, he did not have a workshop of pupils and assistants. He experimented briefly with taking trainees during his last summer in Ipswich, in 1759, when Joshua Kirby's son William (1743–1771) and another youth identified only as 'Master W' were with him, but after that his one and only resident assistant was his nephew Gainsborough Dupont (1755–1797).[5] Young Dupont lived as a member of Gainsborough's family from childhood, presumably because his mother, Gainsborough's sister, was not well off and Gainsborough himself had no son. He was officially made an apprentice in 1772 and from that date he must have helped prepare canvases and colours. As he matured, Dupont began to assist in the painting of portraits, but his contribution was still modest in comparison with that of Reynolds's army of pupils who executed the draperies and backgrounds in most of his portraits. There are no surviving sitters' books to document Gainsborough's routine, but we know that during the latter part of his life he began painting at eleven o'clock, paused for refreshment at one and had his main meal at three in the afternoon. This was reported by his

daughter Margaret, who said that he was generally exhausted by dinner time.[6] This would suggest anything between two and four sittings a day. In Bath in April 1761 one particularly troublesome client was kept sitting between two and four o'clock in the afternoon, as a result of which, to his great annoyance, he missed his meal at his lodgings.[7] Like Reynolds, Gainsborough worked standing. One of Reynolds's sitters described how it was the artist's habit to 'walk away several feet, then take a long look at me and the picture as we stood side by side, then rush up to the portrait and dash at it in a kind of fury'.[8] Judging from some of Gainsborough's brushwork, he probably operated in a similarly lively fashion.

Among Gainsborough's landscapes are a number that feature peasants and animals at rest, generally with an indication that this rest is hard-earned. Gainsborough, who often referred to himself as a 'jackass', seems to identify closely with these animals. The compositions suggest an ideal form of harmonious relationship between human labourers and working animals, be they draft horses or milking cows. In Gainsborough's utopia hard work is a necessary part of life, but is balanced by rest and made tolerable by a properly humane respect for the natural world. His attitude to the animal kingdom may well owe something to Joshua Kirby. Mrs Sarah Trimmer, Kirby's daughter, whose life and career were greatly influenced by her father, was an advocate for the compassionate treatment of wildlife. In *Fabulous Histories*, a small book of 1786 dedicated to Princess Sophia, she encourages the young to observe birds in the wild rather than catch and cage them.[9] Cruelty is an obvious evil in her mind, but mistaken pampering may be almost as bad, and

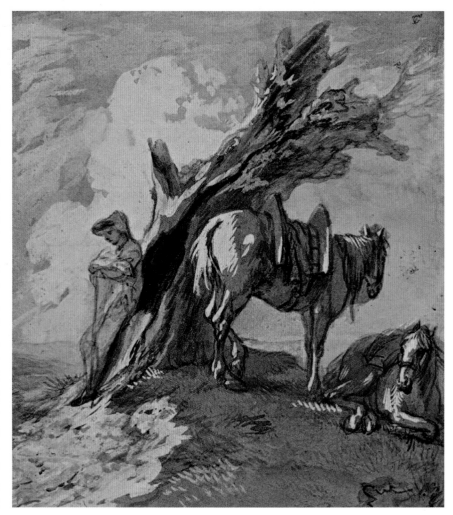

Fig.9 *A Farm Boy with Packhorses resting*, 1760–65
Pencil, grey wash and body-colour on buff paper,
25.4 x 19.5 cm
Private collection
© Sotheby's London

(opposite)
13. *Wooded Landscape with Horses resting*, 1775–80
© Tate, London 2011

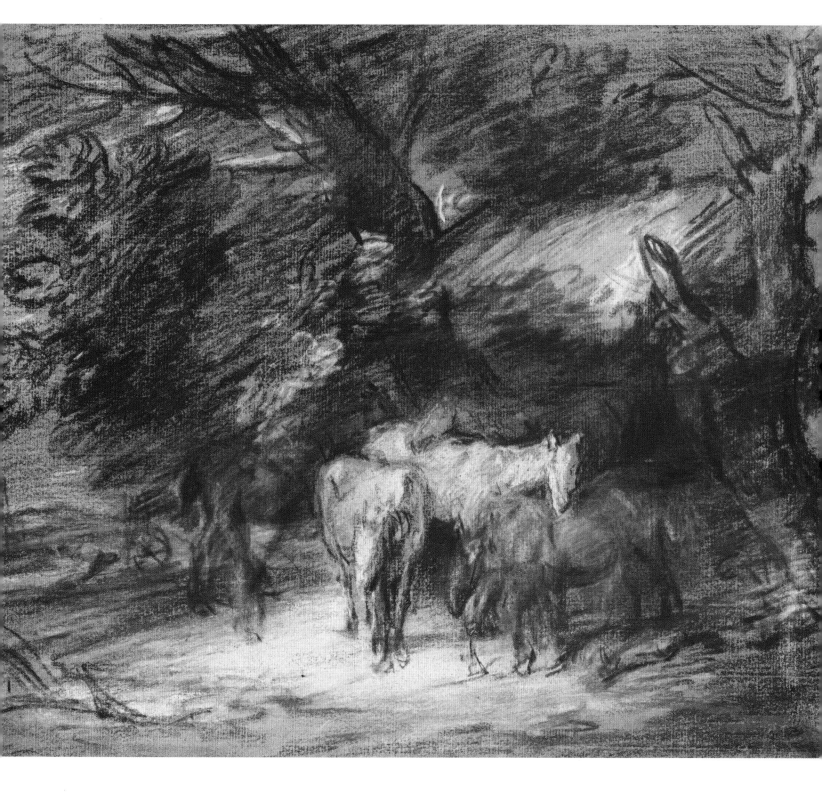

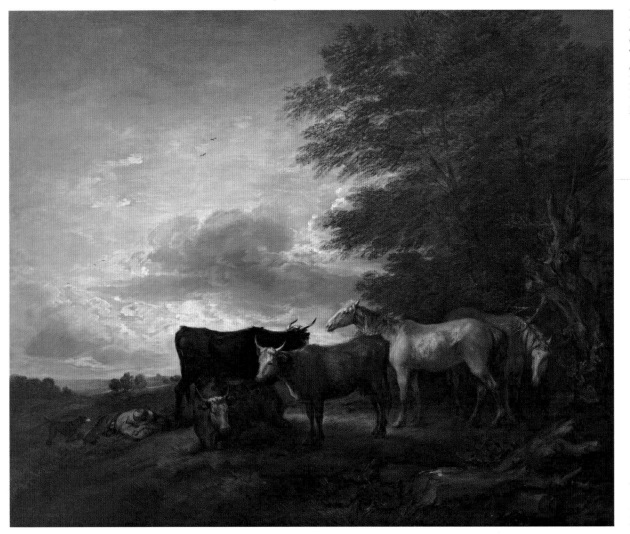

Fig.10 *Landscape with Horses
and Cows: 'Repose'*, 1777–78
Oil on canvas, 122.3 x 149.6 cm
The Nelson-Atkins Museum
of Art, Kansas City, Missouri.
Purchase: William Rockhill
Nelson Trust, 31-56;
photograph Jamison Miller

(opposite)
14. *Wooded Landscape with
Milkmaids and Cows*, 1785–88
Reproduced by kind permission
of Colchester and Ipswich
Museum Service

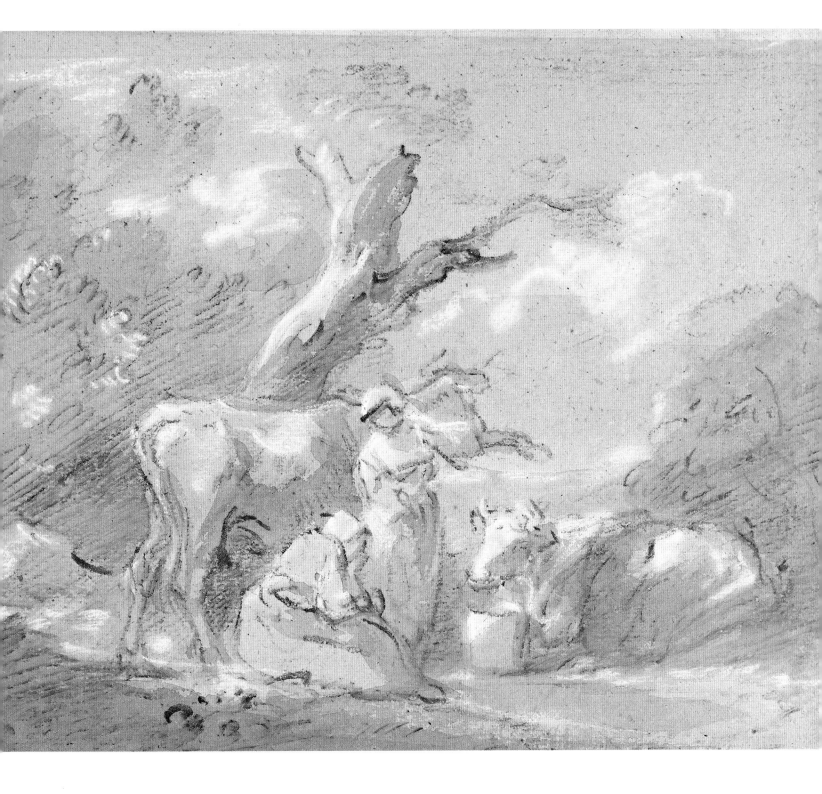

the right course is to allow animals to live naturally. Her message is a simple one, but quite unusual for the period.

The meditative *Wooded Landscape with Two Carthorses* (no. 12) of the mid-1750s, is a haymaking scene, and one of the first to explore the theme of repose. It was painted for the Fourth Duke of Bedford through the agency of Joshua Kirby who received payment for it and another landscape on Gainsborough's behalf in November 1755.[10] The landscape is coloured by a warm light suggestive of evening. In the middle distance two men are still loading hay on to a cart, while in the foreground the two horses that form the main subject of the picture have been unharnessed and brought into the shade to rest and cool their feet at the edge of a pond. This oil is one of the most carefully composed pictures Gainsborough had painted to date. The sheltering oak tree, dark foreground and bright horizon unify the whole, as does the colour. When Sir Joshua Reynolds wrote with advice to Nicholas Pocock, he observed that his seascape lacked harmony, and told him,

> Whatever colour predominates in a picture, the colour must be introduced in other parts; but no green colour, such as you have given the sea, can make a part of a sky… however the sea may appear green, when you are looking down on it, and it is very near – at such a distance as your ships are supposed to be, it assumes the colour of the sky.[11]

Reynolds was repeating the guidance of Jonathan Richardson who cites the example of Raphael's cartoon *St. Paul Preaching* in which the drapery of St. Paul is red and green. Small areas of these same colours are judiciously scattered across the rest of Raphael's composition. In Gainsborough's picture the creamy-white of the principal horse is repeated in the tower of the church and wall of the house on the right. There are also flashes of white on the breasts of the ducks dabbling in the pond. The white church tower is caught in a reflection in the pond, as is the warm red of the tiled roof. One of the most inspired aspects of this composition is the handling of light, especially the manner in which the tree shades the grey horse, leaving only the hindquarters of the animal and the tip of its nose in the sun. The larger patch of white on the hindquarters makes a bright off-centre pool of light that lies immediately beneath the brightest part of the sky. The critic who wrote about the composition of Gainsborough's bridge painting of 1781 (fig. 6), noting that the white cow cleverly introduced a point of light near the centre of the picture, would have recognised the skill with which the same device is employed here, nearly thirty years earlier.

In each of Gainsborough's drawings of horses or cows at rest there is a tree forming a diagonal, enclosing the composition; there is also always a contrast between a light and a dark animal, with the illumination of the scene organised as Richardson recommends, the brightest parts being near, but not exactly at, the centre. The animals and figures are, in every case, quite large within the picture space. A Bath-period drawing of two packhorses and their young minder (fig. 9) has a blasted tree at the centre, supporting the man, while the horses doze, one lying and one standing, their burdens having been unloaded from their backs. The paper has discoloured, but this remains a beautiful and evocative study. A drawing of two cows and milkmaids from twenty years later is a boldly-executed work in chalks and wash (no. 14). The tree

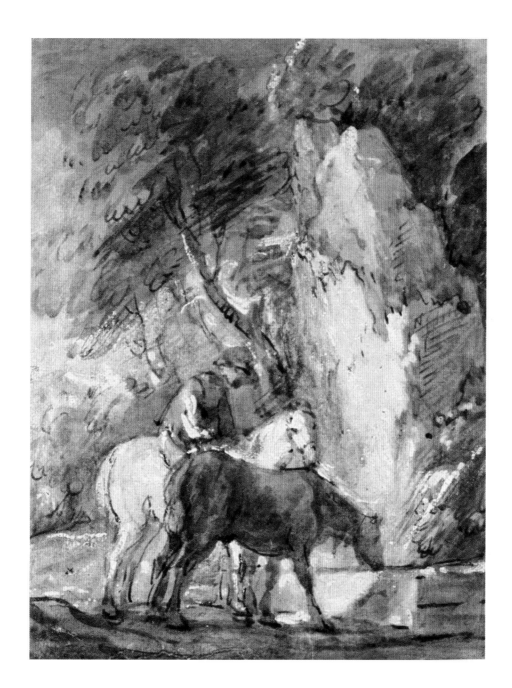

Fig.11 *Horses drinking
at a Trough*, 1779–80
Wash and bodycolour,
varnished, 24.3 x 18.6 cm
Private collection
© Sotheby's London

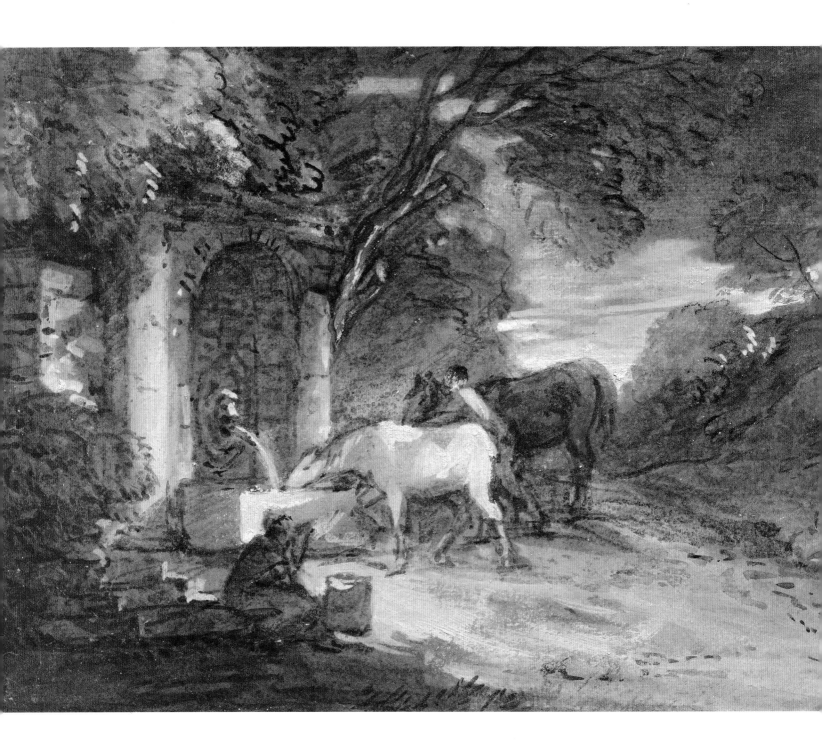

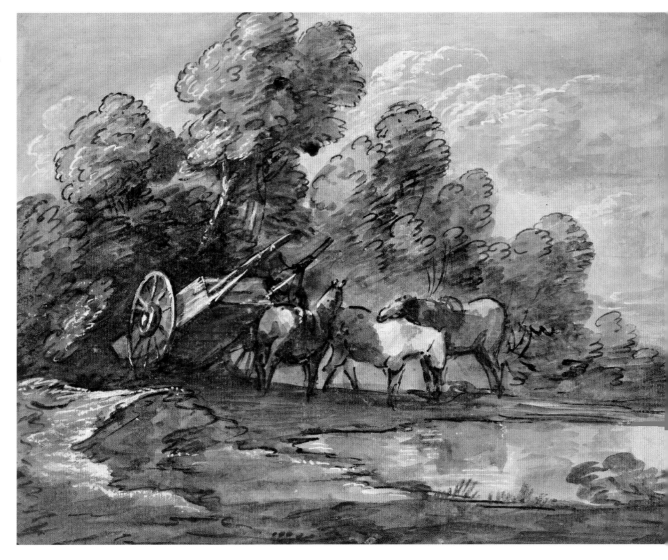

Fig.12 *A Market Cart with Horses by a Stream*, 1780–85
Grey wash, traces of black chalk, heightened with white, on buff paper 26.7 x 34.8 cm
Harvard Art Museum, Fogg Art Museum, Bequest of Grenville L. Winthrop. 1943.708
Imaging Department
© President and Fellows of Harvard College

(opposite)
15. *Wooded Landscape with Horses drinking at a Trough*, 1785–88
Reproduced courtesy of the lender

here is also a pollard or blasted oak offering no shade but still providing a vital diagonal accent.

The group of resting horses in the Tate collection (no. 13) is drawn in an almost frenzied manner, with black and white and coloured chalks on grey paper. It is dateable to the mid or later 1770s. The composition of this drawing also appears in the form of a soft ground etching of around the same date.[12] The earliest recorded owner of the Tate drawing was Henry Bate. In his paper the *Morning Post* Bate first wrote about the artist at the time of his return to the Royal Academy in 1777 after an absence of four years. At that time Bate declared the *Watering Place* (no. 20) 'a masterpiece of its kind', but thought it ill-placed in the exhibition.[13] Gainsborough himself was regularly infuriated by the hanging of his works at the Academy – it was either too high or too low – and it is possible this drawing was a 'thank you' to Bate for publicising his own opinion.

The Duke of Bedford's two resting horses is a masterpiece of the 1750s and Gainsborough's only other oil of two horses is his 1780 Academy exhibit *Horses Drinking* which likewise features contrasting grey and bay workhorses with a carter or ploughman seated on the grey.[14] A related drawing of two horses drinking at a trough is now in an English private collection (fig. 11). A further variation on this theme (no. 15) has two horses drinking from an elegant fountain with a lion's-head water spout, the kind of feature one would expect to find in a landscape garden rather a working farm. This is a complex drawing in a mixture of media, probably later than the upright composition with drinking horses (fig. 11). The care that has gone into its production suggests that in the mid-1780s Gainsborough's interest in this theme was still very much alive. The fountain as a compositional motif occurs in the late *Romantic Landscape* (no. 30). A drawing of three horses released from a cart (fig. 12), again from the last decade, has one weary animal resting its head on the back of another, harking back to the oil of 1755. Gainsborough's feeling for these animals is unmistakeable and his drawing of horses is as accomplished as that of his contemporary George Stubbs (1724–1806), although in Gainsborough's case the draughtsmanship is based on observation rather than scientific enquiry. His horses are noticeably less well-bred than those painted by Stubbs. When he lived in Bath, Gainsborough was given a horse by his patron and friend Sir William St. Quintin. The Yorkshireman St. Quintin was a well-known breeder of racehorses but the horse he gave Gainsborough was no thoroughbred. It is affectionately described by the artist as 'not handsom but perfectly sure footed & steady upon the Road', this being an important consideration in an area of unusually steep hills.[15] Gainsborough received this gift of a horse following a serious illness, 'a Nervous Fever' he had suffered in 1763. Doctors in Bath and elsewhere prescribed riding as a means of restoring health, the exercise being considered especially efficacious in the treatment of headaches and nervous conditions. Gainsborough reported that at this time he rode out every afternoon, except in pouring rain, and the remedy seems to have worked, as he recovered his health.

The composition of the Tate drawing (no. 13) is rearranged in a painting often called *'Repose'*, now in Kansas City (fig. 10).[16] The principal horse in this oil is certainly 'not handsom' – it would be nice to think it was modelled on Gainsborough's own animal

– but is full of character, and is shown resting contentedly with another horse, a group of cows and a sleeping cowherd. Gainsborough attached particular importance to this painting and worked on it over a number of years. He kept it as a wedding gift for Margaret, the younger of his two daughters, but in the event she never married.[17]

It was reported by Bate in the *Morning Herald* of 8 April 1786 that 'Mr. *Gainsborough* has of late been exercising his science upon some of those subjects in rustic nature, on which the attention dwells with the fondest pleasure'. He had painted 'seven imaginary views', all of which were on view at Schomberg House in a display that was timed to coincide with the Royal Academy exhibition that traditionally opened at the end of April. The largest of the seven landscapes is described in some detail:

> a romantic scene. Broken ground, water, sloping trees, and extended upland. In the foreground, near a cottage, three horses are seen with pack saddles on them, one is laid down to rest, and the whole seem as if weary. The driver appears near at hand, and some cottagers complete the number of figures. The sky of this piece is painted with the most exquisite touches, and the clouds marked with uncommon brightness and serenity.[18]

This landscape with pack horses (or just possibly a version of it) now belongs to the University of Wisconsin.[19] A drawing of a similar subject that is, if anything, more satisfactory in design than the Wisconsin painting, is in the collection of the National Trust for Scotland at Brodick Castle.[20] Here, near the end of his life, Gainsborough returns to the motif of working horses to express the idea of well-earned rest. Bate picked his words with care when he described the seven landscapes as 'imaginary views, the materials of which are in the utmost harmony of composition'. In the last decade he, above all other journalists, had access to Gainsborough's innermost thoughts and we can be sure that to achieve 'the utmost harmony of composition' was the artist's personally expressed goal.

NOTES

1 Hayes 2001, no. 40, p. 68, to William Jackson, 4 June, year unknown.
2 Angelo 1969, I, p. 171.
3 Ibid., p. 170.
4 Hayes 2001, no. 46, p. 80, to James Unwin, 10 July 1770.
5 Owen 1996, pp. 65–66 and p. 73, note 51, p. 74, note 60.
6 Farington 1978–98, IV, p. 1152, entry for 5 February 1799.
7 Susan Sloman, 'Sitting to Gainsborough in Bath in 1760', *Burlington Magazine*, CXXXIX, no. 1130, May 1997, p. 327.
8 Richard Wendorf, *Sir Joshua Reynolds: The Painter in Society*, London 1996, p. 115.
9 Mrs [Sarah] Trimmer, *Fabulous Histories. Designed for the Instruction of Children*, London 1786.
10 Owen 1996, p. 65 and p. 73, note 52. For this picture see also Hugh Belsey, *Thomas Gainsborough, A Country Life*, London, Munich and New York, 2002, pp. 60–63.
11 Ingamells and Edgcumbe 2000, no. 86, pp. 87–88, Reynolds to Nicholas Pocock, 4 May 1780.
12 Hayes 1971, no. 8, pp. 59–61.
13 Quoted in Hayes 1982, II, under no. 117, p. 467.
14 Hayes 1982, II, no. 124, pp. 480–82. The painting is now in a European private collection.
15 Hayes 2001, letter no. 10, p. 21, to James Unwin, 15 September 1763.
16 Hayes 1982, II, no. 119, pp. 469–71.
17 Ibid., p. 471.
18 *Morning Herald*, issue 1701, 8 April 1786, p. 3.
19 Hayes 1982, II, no. 162, pp. 540–41.
20 Hayes 1970, I, no. 350, p. 190.

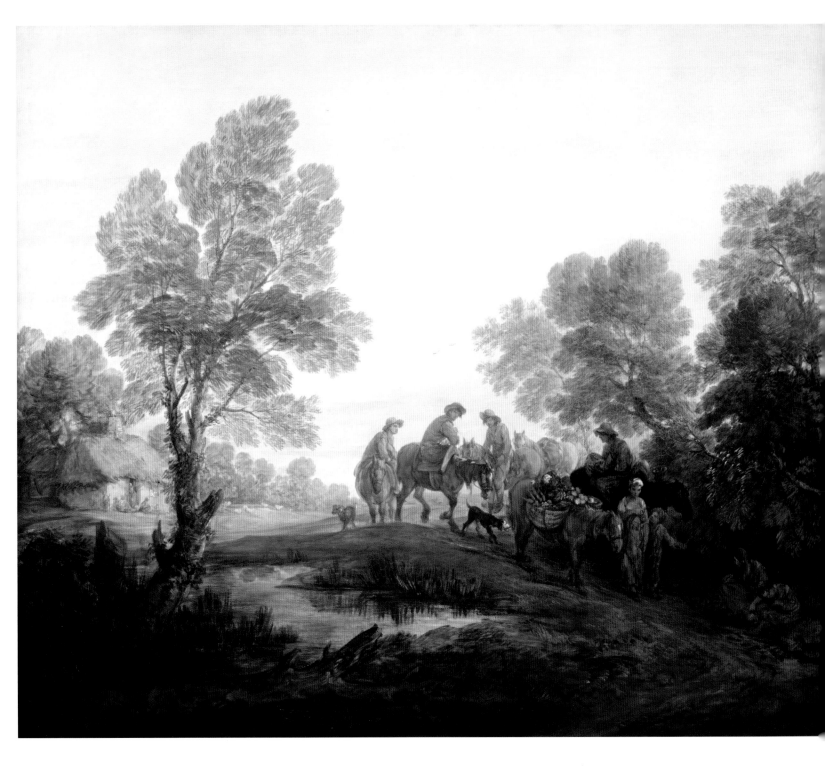

3. 'Charity and humane feelings'

SEVERAL OF Gainsborough's paintings from the middle (Bath) period of his life feature riders and packhorses on a road, either going to, or returning from market. The subject naturally provided an opportunity to depict the silvery light of dawn or the warmth of evening, and this must partly account for its appeal to the artist. The oil from Kenwood exhibited here (no. 16) almost certainly represents evening, as it includes, in the background, a cottage against whose door a family rests, as if after work.[1] The picture originally belonged to John, Second Viscount Bateman (1721–1802) a Member of Parliament and courtier with a London residence and a country estate in Herefordshire. Just as Gainsborough almost always associates a bridge with a ruined building, so he links travelling peasants with beggars, and in Lord Bateman's picture there are two dejected-looking and raggedly-dressed figures sitting at the wayside. Such compositions are not unprecedented and examples by such artists as the Italian Marco Ricci (1676–1730) would have been known to Gainsborough (fig. 13). The important difference between this and one of Gainsborough's landscapes with travellers is that in Gainsborough's hands the image is made timeless by the transformation of the passers-by into peasants. One of the defining qualities of the fancy picture as conceived by Gainsborough is its timelessness (see no. 25) and his landscapes with travellers are essentially fancy pictures with small-scale figures. Ricci's travellers are, by virtue of their fashionable dress and carriage, inseparable from the period in which they were drawn.

Gainsborough was a man given to spontaneous and generous acts of charity. Someone who remembered him from his Ipswich days recalled that his manner endeared him to 'all with whom his profession brought him in contact, either at the cottage or the castle…' and that he saw 'the aged features of the peasantry lit up with a grateful recollection of his many acts of kindness and benevolence'.[2] In 1777, when his family was away from London, Gainsborough wrote urgently to his sister Mrs Mary Gibbon, asking for a loan of £20. This, he confided, was to provide relief for a poor woman he had known in Bath and who had now been abandoned by a lover and left in dire straits in London. The artist did not wish to reveal his action to his wife for fear of its being misconstrued, but told Mrs Gibbon 'as God is my Judge I do what I do more from Charity and humane feelings than any other Gratifycations'.[3] Immediately after his death, obituary writers paid special attention to the charitable side of Gainsborough's nature,

(opposite)
16. *Landscape with Travellers returning from Market*, c.1770
© English Heritage Photo Library

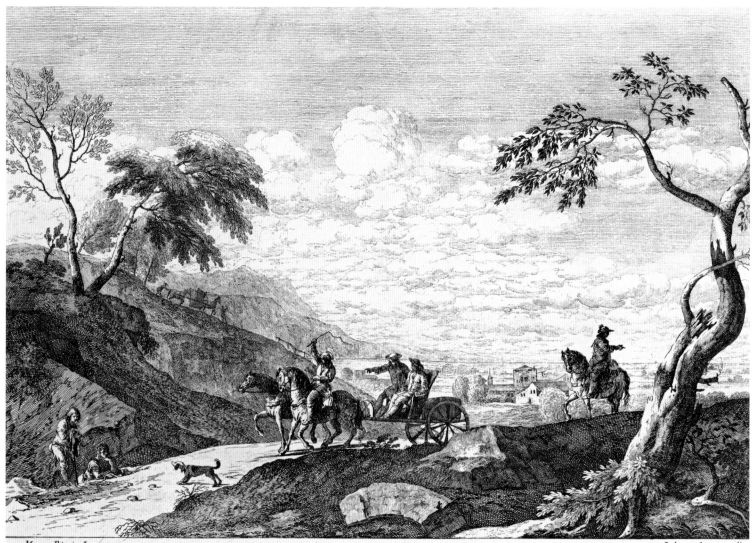

Marc: Ricci Inu: Iulian: Gampiccoli

Fig.14 *Wooded Landscape
with Figures and a Donkey,*
1755–60
Pencil, 16 x 20.6 cm
The Museum of Fine Arts,
Houston; The Stuart
Collection, gift of
Mrs Robert C. Stuart and
Mrs Philip Koelsch

(opposite)
Fig.13 Giuliano Giampiccoli
(1703–1759) after
Marco Ricci (1676–1730)
Landscape with Travellers
Etching, 25 x 36 cm
(to plate mark)
British Museum, London.
1871,082.3964
© The Trustees of the British
Museum

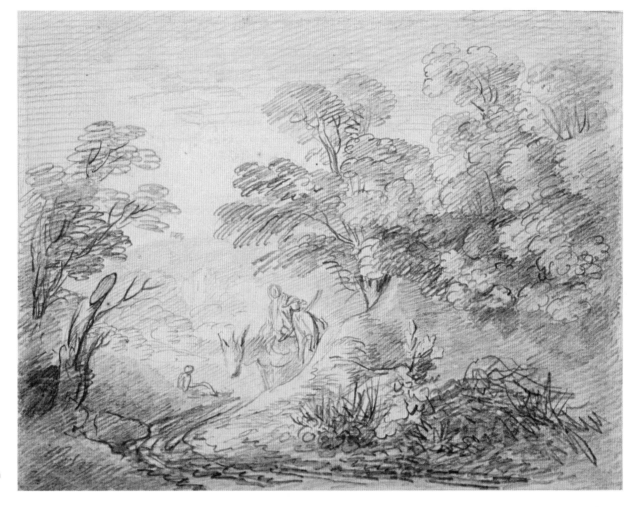

while we lament him as an artist, let us not pass over those virtues, which were an honour to human nature! – Let a tear be shed in affection for that human heart, – whose strongest propensities were to relieve the claims of poverty, wherever they appeared genuine! – His liberality was not confined to this alone, – needy relatives, and unfortunate friends were further encumbrances on a spirit that could not DENY.[4]

Another obituary says much the same, adding, 'if he selected, for the exercise of his pencil, an infant from a cottage, all the tenants of the humble roof, generally participated in the profits of the picture: – and some of them frequently found in his habitation a permanent abode'.[5] The theme of charity may also lie at the heart of the famous 'Cottage Door' compositions which seem to reflect the activities of one of the best-known charitable foundations of Gainsborough's day, the Foundling Hospital. The hospital took in abandoned infants and placed them with country-dwelling foster mothers until they were old enough to be educated.[6] Each foster-mother was chosen for her health and character, the suitability of her home and the good air of the district in which she lived. Gainsborough's smiling women at cottage doors can be seen as ideal Foundling foster-mothers watching over their brood of charity children. A further painting that takes charity as its subject is *Charity Relieving Distress* that was on show at Schomberg House in 1784.[7] In this, a group of poor women and children receive kitchen scraps outside the door of a grand town house.

In considering the Kenwood landscape it is of particular interest to discover that Lord Bateman, for whom the picture was painted, was a notable almsgiver in the neighbourhood of his country seat at Shobdon. A newspaper report speaks of him in his old age distributing sizeable sums of money to rural paupers: 'Lord Bateman, an amiable old Nobleman of 80 years who lives constantly in Herefordshire, every morning has silver, to the amount of a guinea, put on his breakfast-table, to distribute to the poor in his walks'.[8] Lord Bateman was a friend of Philip Thicknesse (Gainsborough's supporter and first biographer) one of his only long-term friends, in fact, as Thicknesse was a notoriously unreliable and querulous man. As well as purchasing the *Landscape with Travellers*, Bateman commissioned from Gainsborough one or more portraits of his mistress Miss Elizabeth Tyler, a fiery young woman who was the daughter of the vicar of Shobdon.[9] He also owned a number of Gainsborough's drawings.

It can be argued that Gainsborough chose to inhabit his landscapes only with peasants in order to widen the significance of the pictures, and make them comparable with the works of the Old Masters, but the figures he depicts are based on his observations of real country people. Michael Rosenthal has written eloquently on the Kenwood landscape and other pictures of this kind, pointing out that Gainsborough's peasantry and beggars represent different levels of rural poverty.[10] The poor at this time fell into a surprising number of categories and included some who could afford to hire labour. A foreign visitor to England in 1786 noted the distinction between peasant farmers and farm-hands who she saw at a fair in the village of Staines, near London: 'Farm-hands and maids very cleanly dressed, bunches of flowers in their hats, stood here seeking employment, and were selected on the spot by peasants and peasant-women

and taken right away with them.'[11] We may assume that the principal figures in Gainsborough's groups of travellers are peasant farmers and not farm-hands, who would not have possessed horses.

Beggars at the wayside were a common sight, even in such unexpected places as the Marlborough Downs, an area crossed daily by coaches journeying between London and Bath. A traveller heading for Bath in 1775 (just four or five years after our picture was painted) described the poor chalky soil between Newbury and Chippenham and the beggars: 'for miles together the coach was pursued by them, from 2 to 9 at a time – almost all of them children – They are more importunate than in Ireland or even Wales'.[12] The motif of travellers passing beggars sometimes appears in Continental European art in the guise of a *Flight into Egypt*.[13] One of the earliest of Gainsborough's drawings of travellers, a pencil sketch of the early 1750s that he gave to Joshua Kirby, and is now in Houston, looks very like a *Flight into Egypt* (fig. 14). Intriguingly, in the mid 1760s William Jackson suggested Gainsborough paint the subject of the *Flight*. Gainsborough's response to such a high-flown idea is robust and dismissive. He agrees that 'there might be exceeding pretty Pictures painted' of that type, but says that he prefers to 'fill up' his pictures with 'dirty little subjects of Coal horses & Jack asses and such figures'.[14] The Kenwood travelling peasants and two other oils of the same subject, all painted in Bath, do seem to include coal horses as well as peasant farmers.[15] In each case the little cavalcade is headed by peasants bearing produce and followed by a secondary group of somewhat shadowy male riders without baskets. These look very like miners and it is a fact that the oil painting of market travellers originally at Stourhead in Wiltshire was, in early inventories, called 'Peasants and Colliers' or 'Peasants and Colliers riding to Market'.[16] Colliers and agricultural workers peopled the roads around Bath in almost equal numbers. The availability of cheap local coal was one of the reasons Bath became a favourite winter resort for gentlemen and ladies of leisure. The steep hills that separated Bath from the many small mines to the south and west of the city made large carts almost redundant, and coal was regularly carried in sacks on pack ponies. When travelling to or from work, or returning from market, the colliers perched on the wooden saddles that were designed to bear their sacks. Bath's colliers were a proud, God-fearing and clannish group who were contemptuous of the moneyed classes who, they believed, 'will march directly to the D[evi]l as soon as they die'.[17] When riding on the road the colliers did not willingly make way for grand carriages. Complaints were commonly made about their insolent behaviour, but the local reformer Edmund Rack thought it just as well that they were blessed with a sense of moral superiority, since without it their lives would have been even more wretched than they were.

The late Bath-period landscape with travellers from Birmingham (no. 17) is a technically complex drawing, apparently made in the manner Gainsborough divulged to Jackson in his letter of January 1773.[18] The dry white highlights are made with the 'Bristol made white lead which you buy in lumps at any house painters' that Gainsborough recommended to Jackson, telling him that the lumps could readily be sawn into suitable shapes to be used as chalk.[19] The Bristol house-painters' white lead, he

says, is harder and more like chalk than the London equivalent. This drawing, which shows a rider with pack horses moving away from us, is stamped with Gainsborough's monogram 'TG' which suggests it was made as a gift.

Although the three related paintings of travellers with pack ponies were made in Bath, Gainsborough still drew the subject after moving to London. The British Museum varnished drawing (no. 18) probably dates from the early 1780s and includes the crumpled figure of a beggar seated beneath a leafless tree. Another study from the same collection is one of a large number of faded brown wash drawings with brown outlines that also belong to the late 70s and the 1780s (no. 19). The technique used here has long puzzled commentators, and the slightly waxy-looking lines are often called 'offset' outlines. John Hoppner sometimes used what looks like the same medium, and it is suggested here that Gainsborough and Hoppner were using a pencil made with a bituminous material.[20] At this time Gainsborough started using bitumen in his oil paint; he had also been experimenting with soft ground etching and aquatint, printing techniques that involve the use of bitumen.[21] Joseph Farington (who was a professional artist as well as an indefatigable diarist) spoke of drawing with asphaltum, which is bitumen mixed with clay.[22] The last travellers drawing reproduced here (fig. 15), a beautiful fluid study dating from the 1780s, harks back to the painting of *Peasants and Colliers going to Market* of 1773, originally at Stourhead. It depicts market figures, one with a hen basket, and a pair of donkeys, but no colliers, and in this case, no beggars.

Gainsborough does not pass judgement on the figures he depicts and his own tongue-in-cheek remark about using them to 'fill up' a picture does not encourage us to seek a moral message in these compositions. The pictures cannot fail to evoke feelings of sympathy for the poor, however. Gainsborough's personal acts of charity and his fancy pictures (which we can take to include the landscapes with travellers) mark him out as a man of sensibility. His contemporaries admired these works above all others and associated the theme of charity with him. Horace Walpole, who annotated his Royal Academy catalogues with comments on pictures that caught his eye, noted 'In the manner of Gainsborough' against *A Landscape, the Farmer's Compassion to the Distressed Soldier*, by Philip Jacques de Loutherbourg (1740–1812) in his 1783 catalogue.[23] Since de Loutherbourg's technique is entirely different from Gainsborough's, Walpole must have meant that the subject, composition or sentiment of the picture reminded him of Gainsborough.

NOTES

1 Rosenthal 1999, pp. 202–4.
2 Fulcher 1856, pp. 48–49.
3 Hayes 2001, no. 81, pp. 135–36, to Mrs Mary Gibbon, 22 September 1777.
4 *Whitehall Evening Post*, issue 6425, 2–5 August 1788, p. 3.
5 *Morning Chronicle*, issue 6003, 5 August 1788, p. 4.
6 Sloman in Bermingham 2005, pp. 37–51.
7 Waterhouse 1966, no. 988, p. 120.
8 *St James's Chronicle*, issue 6406, 8–10 January 1799, p. 4.
9 Waterhouse 1966, nos.685, 686, p. 93.
10 Rosenthal 1999, p. 202.
11 Sophie v. la Roche, *Sophie in London 1786, being the Diary of Sophie v. la Roche*, translated and introduced by Clare Williams, London 1933, p. 205.
12 Thomas Campbell, *Dr Campbell's Diary of a Visit to England in 1775*, James L. Clifford, ed., Cambridge 1947, p. 87, entry for 29 April 1775.

(opposite)
Fig.15 *Landscape with Peasants returning from Market*, 1780–85
Grey and brown washes, 19.4 x 24.4 cm
Private collection
© Sotheby's London

13 Rosenthal 1999, p. 202.
14 Hayes 2001, no. 22, p. 39, from Bath, dated only 23 August, but probably 1767.
15 The other compositions are Hayes 1982, II, no. 98, pp. 442–43 (in the Cincinnati Art Museum) and no. 106, pp. 451–52 (now in a British private collection).
16 Susan Sloman, 'The Holloway Gainsborough: its subject re-examined', *Gainsborough's House Review 1997/98*, 1998, pp. 47–54.
17 Ibid., p. 50.
18 See introductory essay, pp. 9–10.
19 Hayes 2001, no. 64, p. 110, from Bath, 29 January 1773.
20 See two of Hoppner's drawings in the Victoria and Albert Museum, Forster Collection PD 188, *A Woman carrying Sticks on her Head* and the landscape Dyce Collection 686, formerly called Gainsborough (and not accepted by Hayes) here attributed to Hoppner.

21 Hoppner conveyed instructions for soft-ground etching to Thomas Sunderland in September 1788, see C.F. Bell and T. Girtin, 'The Sketches and Drawings of J.R. Cozens: Some Additions and Corrections to the Twenty-Third Volume of the Walpole Society, *Walpole Society*, XXIII, 1935 (additions first published 1947), p. 3. It may be significant that soft-ground etching was in Hoppner's mind at this date, three months after Gainsborough's death.
22 Farington 1978–98, VII, p. 2676, entry for 27 January 1806. Farington had been a pupil of Richard Wilson and was himself a Royal Academician. He says 'Dr. Monro called on me today & expressed a desire to have several of my drawings made with Asphaltum outlines'.
23 William T. Whitley, *Artists and their Friends in England 1700–1799*, 2 vols., London 1928, II, p. 387.

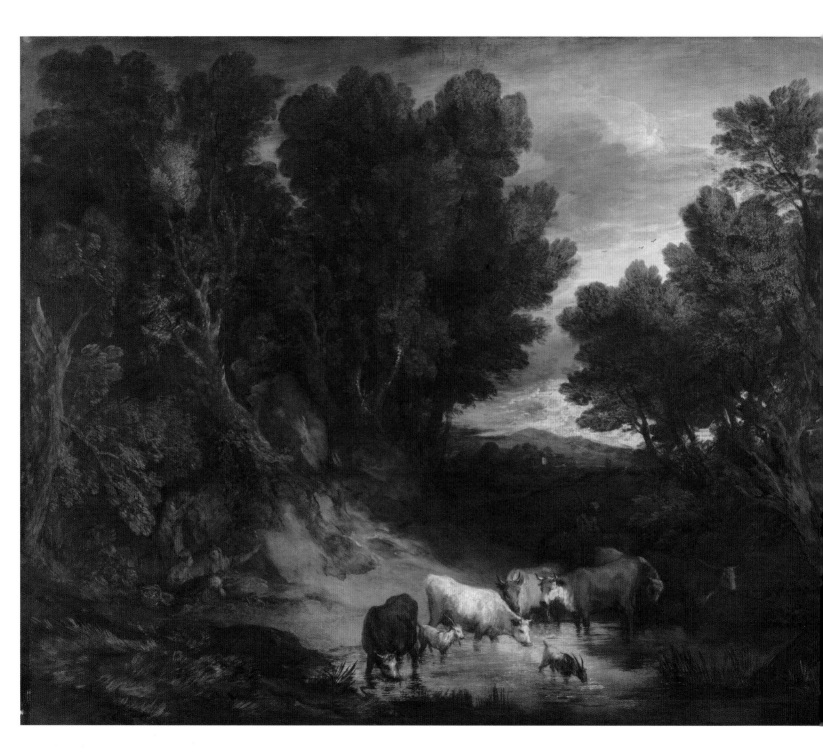

4. 'The mild Evening gleam'

IN A LETTER TO David Garrick, written in the early 1770s, Gainsborough criticizes the current fashion for bright lighting and tawdry colour on stage. He urges Garrick to return to 'modest truth' and 'the mild Evening gleam', even if this might at first appear gloomy.[1] He classes modern theatre, music and art together, believing all have lost their way and are no longer 'real Works of Invention, but the abuse of Nature's <u>lights</u>, and [wha]t has already been invented i[n] [form]er Times'. True creativity, he infers, does not turn its back on tradition. One of the paradoxes of Gainsborough's art is that it often appeared to his contemporaries startlingly novel, but it was based on an almost reverential respect for the past.

The Kenwood *Landscape with Travellers* is just one example of Gainsborough's many landscapes that are bathed in evening light. The *Watering Place* (no. 20) is easily the most majestic evening scene painted in the 1770s. It is no accident that there are a large number of drawings relating to this composition. It was one of the artist's most carefully considered landscapes, and the theme was one that he continued to explore long after painting the oil now in the National Gallery. This painting was much mentioned in the press when it hung in the Royal Academy in 1777 and it is likely to be one of the pictures that Henry Bate had in mind when he wrote in his friend's obituary,

> His mind was most in its element while engaged in landscape. These subjects he painted with a faithful adherence to Nature; and it is to be noticed they are more in approach to the landscapes of Rubens than to those of any other master. At the same time we must remark, his trees, foreground, and figures, have more force and spirit: and we may add, the brilliancy of Claude, and the simplicity of Ruysdael, appear combined in Mr. G's romantic scenes.[2]

The *Watering Place* was not originally so called, but acquired this title in the nineteenth century on account of its perceived indebtedness to Rubens's famous landscape of that name.

The composition, which features two banks of trees, one of greater height and mass than the other, is indebted to Claude, and it should be remembered that Richard Earlom's prints of Claude's *Liber Veritatis* were published in 1774.[3] The application of the paint in Gainsborough's picture is very unlike Claude's and we know that Gainsborough found Claude's handling 'tame and insipid'.[4] The bold technique on show in the *Watering Place* elicited an extraordinary response from a commentator writing under the name 'Gaudenzio' in the *St. James's Chronicle*:

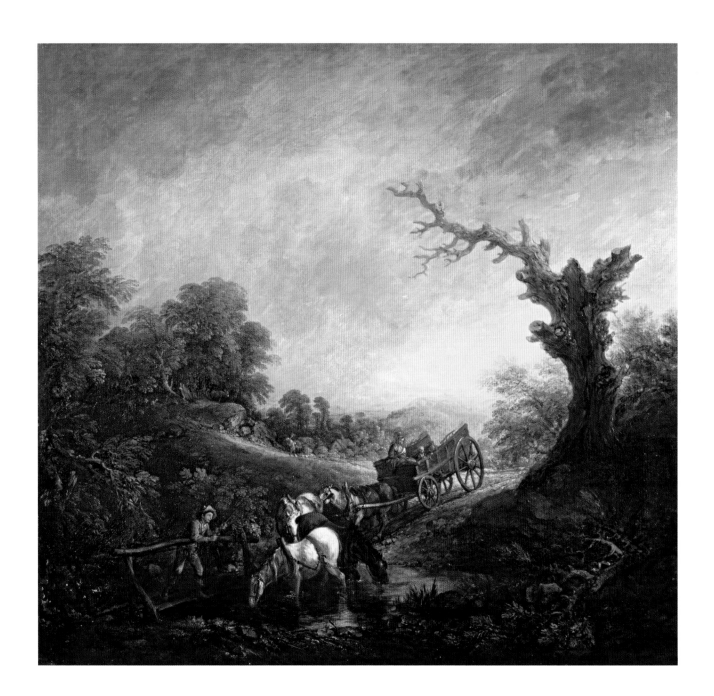

21. *Landscape with a Cottage,
a Herdsman and Cow, c.*1750
Reproduced courtesy
Gainsborough's House

(opposite)
Fig.16 *Carthorses drinking
at a Stream,* 1760–63
Oil on canvas, 143.5 x 153.7 cm
Tate. Presented by Robert
Vernon, 1847. N00310
© Tate, London 2011

[Gainsborough's] large Landscape, No. 136, is inimitable. It revives the Colouring of Rubens in that Line. The Scene is grand; the Effect of light is striking; the Cattle very natural: But what shall I say of the Penciling? I really do not know; it is so new, so very original, that I cannot find Words to convey any Idea of it. I do not know that any Artists, living or dead have managed their Pencil in that Manner, and I am afraid that any Attempt to imitate it will be attended with Ill-success.[5]

We do not know the identity of 'Gaudenzio', who is claimed to be an Italian painter writing home to a fellow artist, but Gainsborough's old friend Philip Thicknesse was closely associated with the *St James's Chronicle* and may have had something to do with this review. When compared with Rubens's considerably smaller *Watering Place*, a picture that is also in the National Gallery, Gainsborough's picture does not appear strikingly Rubensian, but the tonality and depth of colouring is certainly more akin to Rubens than to Claude. The brushwork or 'penciling' is also more like that of Rubens, Van Dyck or even Rembrandt than Claude, and is rich in contrast and in texture. In some parts of the picture the paint is very thin, almost like watercolour; in other areas the highlights are dashed on with thick dabs of colour. The brown cow that has just raised its head from drinking lets fall a thin dribble of water: this tiny raised white accent must have been added with the narrowest of brushes held in the steadiest of hands. The reflective surface of the water is conveyed by means of dragged horizontal strokes of a dryish pigment over darker underpainting. There is a great variety of colour in the foliage, ranging from orangey-brown to dark green and almost black. The

trees are very densely drawn and quite unlike the feathery ash trees in the Kenwood landscape (no. 16).

The composition is arranged according to Richardson's principles, with the white cow strategically placed to catch the brightest light and a patch of luminous sky following the setting sun near the horizon. As in so many of Gainsborough's landscapes, water is an essential ingredient. The use of water as a means of introducing reflected light into the foreground is a time-honoured tradition in the history of landscape painting, and one which is alluded to by Joshua Kirby in his treatise on perspective. Kirby quotes Alexander Pope's *Second Pastoral*, which he says, 'seems an inimitable Picture of Nature …:

> A Shepherd's Boy (he seeks no better Name)
> Led forth his Flocks along the silver Thame,
> Where dancing Sun-Beams on the Waters play'd,
> And verdant Alders form'd a quiv'ring Shade.'[6]

The *Watering Place* may be traced back to one of Gainsborough's earliest imaginative pencil drawings (no. 21). This drawing, now appropriately housed in the Gainsborough's House collection at Sudbury, must date from the beginning of the 1750s or even earlier. It is naïve in many respects and the man and cow are oddly out of scale. Yet elements of the *Watering Place* are all there, a herdsman and cow, a grassy bank and a foreground pool flanked by trees. The idea of animals being taken to water is developed in the sizeable oil painted soon after Gainsborough moved to Bath (fig. 16). Here, as in the *Watering Place*, the animals (in this case horses) head towards us. They pause to drink while the cart behind them lurches awkwardly downhill into the

ford. The water is once again contained in a bowl-like depression in the foreground of the picture. This painting, like the *Watering Place*, is an evening scene, tinged with pink light. The white horse creates a patch of brightness near the centre. Every one of Gainsborough's drawings of similar woodland scenes has water or a bright sandy bank or road to introduce light into the foreground. The animals generally head towards the viewer in a 'v' shaped formation, giving a sense of movement and depth at the centre.

The significance of the National Gallery *Watering Place* cannot be overstated. Following a disagreement over the hanging of his pictures, Gainsborough had shown nothing at the Royal Academy between 1773 and 1776. This was therefore the first of his landscapes to be seen in a public exhibition since his arrival in London in the autumn of 1774. It may have been painted at any time between 1774 and the spring of 1777. It is worth looking at what was happening at the Royal Academy during this period of absence and what was being said about other landscape exhibitors, bearing in mind the fact that Gainsborough was sensitive to what was written in the press. It is possible that the *Watering Place* was, at least in part, a response to a much-admired Academy exhibit by George Barret. The Irishman Barret was, like Gainsborough, a foundation member of the Academy. He had arrived in London in 1762 and exhibited thirty-one landscapes between 1769 and 1782, many of them pastoral subjects. Richard Wilson was also a foundation member and was still active in the 1770s but his subjects were very different, *Castel Gandolfo* and the *Cataract of Niagara*, for example, being among his exhibits in 1774. Barret in 1775 showed five landscapes, one of which was singled out for particular praise. This was *Morning – a Landscape with Cattle*, which was described in the *Middlesex Journal* as

everything that a warm imagination can produce. The groups of cattle are admirably disposed; the sunshine true; the plan well conceived, and furnished with the most masterly brush possible. The vast productions of nature, when sporting in the fields, amongst rocks, trees, cattle and rural figures of every sort, are subservient to [Barret's] will, and he imitates them so well, that it may with truth be said, he adds to their beauties, and not impoverishes her works.[7]

Sitting with his newspaper in self-imposed exile at Schomberg House, Gainsborough might well have been concerned that Barret was stealing his thunder. What he read about Barret's *Morning* may have spurred him into painting the *Watering Place*, a picture that was given no title but is clearly a representation of evening. Apart from Barret, the only painter of real stature to attempt similar subjects was de Loutherbourg. His landscapes were, though, Continental in feel and less natural than those of Barret or Gainsborough. One critic spoke scathingly of de Loutherbourg's 'combed cattle', his 'fluttering herbiage' and his illumination that appeared to come from an industrial furnace rather than the rising or setting sun.[8]

Four very beautiful blue paper drawings explore the *Watering Place* composition (no. 23, no. 24, fig. 17 and fig. 18). Two of these drawings (no. 23 and fig. 17) appear to date from the same decade as the painting and have coloured chalk added to the more commonly-used black and white. The Tate drawing (no. 23) has travelling figures rather than animals watering as its

Fig.18 *Wooded Landscape with a Horse*, 1785–88
Black chalk and stump and white chalk on blue paper, 17.8 x 21.6 cm
Art Gallery of New South Wales. Parramore Purchase Fund 1995

narrative theme; the privately-owned sheet (fig. 17) has a road catching the light rather than water. The two later drawings (no. 24, fig. 18) date from the mid-1780s. The one now in Australia (fig. 18) is of particular interest because of the precise way it repeats elements of the composition of the *Watering Place*. The trees and bank on the left are remarkably close, as is the way in which light at the horizon filters between the narrow trunks of the trees on the right. The animals here are imprecise, but seem to be two cows, the nearest of which is shaped like the white cow at the centre of the *Watering Place*. The Manchester blue paper drawing (no. 24) is one of those that shows the artist changing his mind as he works. On the left a bank and sheep are drawn over some trees and in the centre the nature of the travelling figures is unresolved. There even seems at some stage to have been a cottage with a chimney in the middle distance. Gainsborough's mind was evidently as restless as ever, and we can literally see ideas taking shape before our eyes.

Two other drawings make use of different materials. The large sheet from Wakefield (no. 22) is on two joined pieces of paper which have been laid on to canvas. It is partly painted in oils, has been varnished, and belongs to the period around 1771–75 when Gainsborough was experimenting with making drawings in imitation of paintings. He called them 'Cartoon Landskips' and rather disconcertingly told a friend that he intended to make more of them 'as they run off so quick'.9 The privately-owned drawing on white paper (fig. 19) is a watering place, with a pair of lovers looking on, as in the painting. In this variation, which is from the early 1780s, the trees are relatively small, light and airy, and the land-

scape mountainous. The pool is improbably situated at the crest of a hill. This composition is one of those that suggest the metamorphosis of the *Watering Place* into the *Romantic Landscape* (no. 30) and may be compared with the Bedford drawing that has trees changing into rocks (no. 34).

The National Gallery *Watering Place* may be viewed as the seminal 'Gainsboroughesque' landscape, a picture whose influence was felt far beyond the walls of the Academy and Schomberg House. Its effect can indeed be traced in the paintings of other artists and in the ideas promulgated by the writers on the Picturesque, Uvedale Price and Richard Payne Knight.10 It has already been noted that Payne Knight was a collector of Gainsborough's drawings, and owned, for example, the sketchbook study of a bridge that is in this exhibition (no. 3). In his poem *The Landscape*, of 1794, Knight makes his case by comparing a mansion set in an 'improved' landscape designed according to the principles of Capability Brown and one in a Picturesque or unimproved landscape. The latter scene is described in the poem:

> Through the rough thicket, or the flowery mead;
> Till bursting from some deep-embowered shade,
> Some narrow valley, or some opening glade,
> Well mix'd and blended in the scene, you show
> The stately mansion rising to the view.11

He commissioned a pair of drawings to illustrate his text from the watercolourist Thomas Hearne (1744–1817). The Picturesque landscape (fig. 20) has a distant view of a mansion in what appears to be natural countryside, the view being framed by two clumps of trees. The foreground is richly textured

Fig.19 *Landscape with Cattle and Sheep watering and rustic Lovers*, 1780–85
Black and white chalks and grey and grey-black wash, 27 x 35.7 cm
Private collection c/o Lowell Libson Ltd

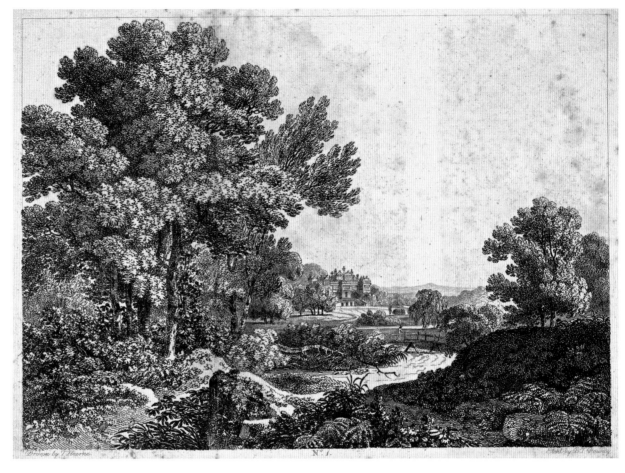

with an irregular waterway and a mass of wild plants intermingling beneath the trees. In the contrasting improved or 'dressed' landscape the 'lonely mansion' is set 'midst shaven lawns', a stream with manicured banks and trees whose untidy lower branches have been removed. If Hearne's 'unimproved' landscape seems to take its cue from the *Watering Place*, we should not be surprised. Hearne owned eight landscape drawings by Gainsborough and was a close friend of Dr Thomas Monro, the owner of 130-plus drawings including two represented here (no. 24 and fig. 18). Hearne himself made at least four copies after Gainsborough.[12]

Hearne would have heartily approved of Charles Long's purchase of the *Watering Place* from Mrs Gainsborough's sale in 1797. The two men were probably acquainted since Long knew a number of watercolourists of Dr Monro's circle. His wife Amelia

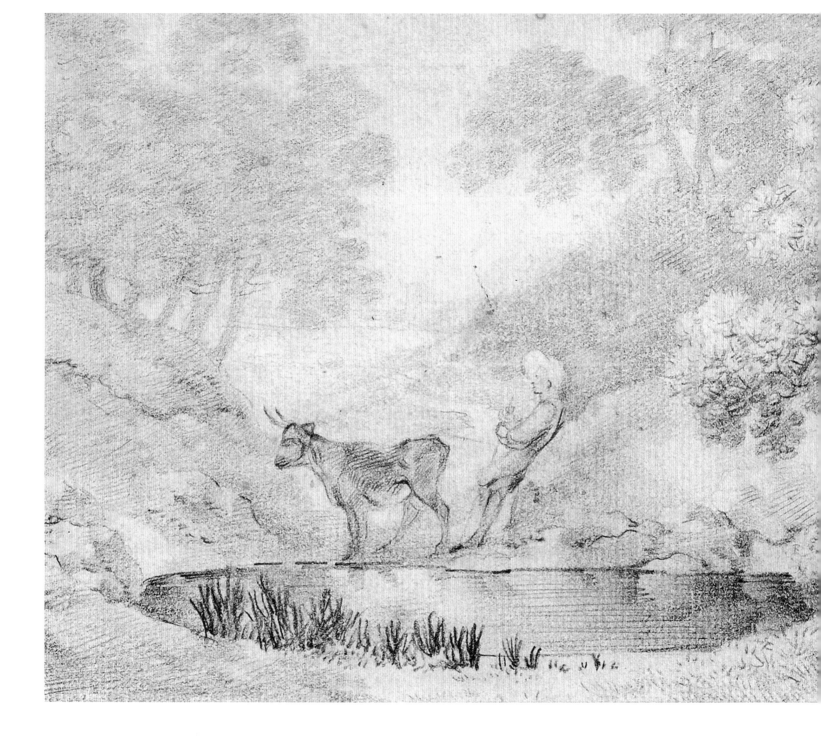

was an accomplished painter who took lessons from Girtin and Henry Edridge, one of Monro's and Hearne's protégés. Soon after buying the *Watering Place* Long wrote 'I have enriched my Collection of Pictures by the best Landskip of Gainsborough I ever saw.'[13] In 1827 Long (by then Lord Farnborough) presented it to the National Gallery, being anxious to ensure that the newly-founded national collection should include works of the most eminent British artists alongside its Old Masters.[14]

NOTES

1 Hayes 2001, no. 63, pp. 107–8, to David Garrick, undated, but probably 1772.

2 *Gentleman's Magazine*, LVIII, no. 2, part 2, August 1788, p. 755, taken from Henry Bate's obituary in the *Morning Herald*, 4 August 1788 (copies of that particular issue of the *Morning Herald* now appear lost).

3 Richard Earlom (1743–1822) produced etchings with mezzotint tone after two hundred drawings by Claude that record the compositions of Claude's paintings.

4 Amal Asfour and Paul Williamson, 'William Jackson of Exeter: New Documents', *Gainsborough's House Review 1996/97*, 1997, p. 64.

5 *St James's Chronicle*, issue 2520, 3–6 May 1777, p. 2.

6 Kirby 1754, p. 74.

7 *Middlesex Journal*, issue 949, 25–27 April 1775, p. 2.

8 *Morning Chronicle*, issue 4048, 9 May 1782, p. 2.

9 Hayes 2001, no. 56, p. 94, to the Hon. Constantine Phipps, 13 February 1772.

10 Bermingham 1987, p. 60. Bermingham points out that Hearne's illustration for Knight's poem borrows from 'the typical Gainsborough landscape'.

11 Richard Payne Knight, *The Landscape: a Didactic Poem in three Books addressed to Uvedale Price Esq. by Richard Payne Knight*, London 1794, pp. 15–16.

12 Morris and Milner 1985, no. 88, p. 95.

13 Judy Egerton, *National Gallery Catalogues, The British School*, London 1998, p. 111.

14 Ibid., note 22, p. 113. A slightly different sequence of events is described on p. 11 of the same publication; that on p. 113 appears to be correct.

(opposite detail)
21. *Landscape with a Cottage, a Herdsman and Cow*, c.1750
Reproduced courtesy
Gainsborough's House

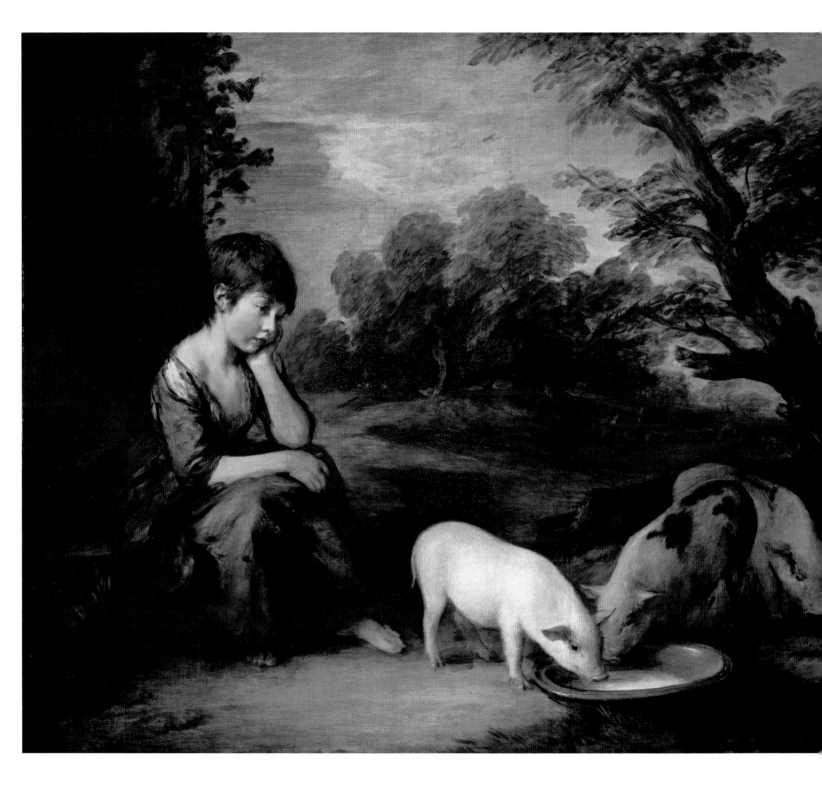

5. 'Avoiding great subjects'

GAINSBOROUGH WROTE IN April 1783 to his friend the architect Sir William Chambers, mentioning his 'fighting dogs', a picture he had submitted to the Academy that year. Making light of its humdrum subject matter he says 'you know my cunning way of avoiding great subjects & of concealing my ignorance by a flash in the pan'.[1] Chambers was Treasurer of the Royal Academy and a member of the Committee of Arrangement, the group of Academicians that was responsible for placing the exhibits in the Great Room and secondary rooms at Somerset House. The *Fighting Dogs* and the *Girl with Pigs* (no. 25), which was shown at the previous year's Academy, are what were called fancy pictures. The fancy picture was not a 'great subject' like a history picture, it did not necessarily have a moral tale to tell, but was a branch of figure painting in which sentiment was expressed through the depiction of 'simple' characters. The fancy picture provided an opportunity for a painter to exercise his imagination and advertise his technical skills. Its subjects (often children) were not meant to be recognized as portraits, although certain artists, including Reynolds, Nathaniel Hone and Gainsborough sometimes used family members as models. By portraying these anonymous figures in a landscape, and in ragged or generalized dress, the artist could create images that

transcended time: a beggar painted by Gainsborough could be compared with one painted by Rembrandt or Murillo.

The fancy picture had a long history and was, as Martin Postle has said, 'a nebulous, multifaceted and ambiguous genre'.[2] It became very popular in London in the 1770s and 80s, partly because it broke up the ranks of portraits in the public exhibitions. A newspaper reviewer anticipating the Academy show of 1789 said, 'It is the general wish, that the Royal Academy will, on its opening, display fewer portraits, and more historical and fancy pictures than we have lately witnessed'.[3] The rise of the fancy picture coincided with a 'back to nature' fever that swept through certain sections of society in the wake of the fashion excesses of the 1770s. Women's hairstyles were particularly tall and highly ornamented at this time. They could sometimes incorporate (in Hannah More's words) 'an acre and a half of shrubbery besides slopes, grass-plats, tulip-beds, clumps of peonies, kitchen gardens, and green-houses'.[4] These creations were both impractical and unhygienic and were regarded by some as symbols of an increasingly decadent society. Caricaturists had fun portraying women having their hair dressed by men on ladders, getting their coiffure stuck inside sedan chairs and even having it catch fire as a result of touching chandeliers.

(opposite)
25. *Girl with Pigs*, 1781–82
From the Castle Howard Collection

In response to the extreme hair and heavily decorated and beribboned dresses, simpler hairstyles and plainer fabrics made an appearance, and there was a vogue for the wearing of white and off-white, fostered by famous female beauties such as Mrs Mary Robinson and the Duchess of Devonshire. Gainsborough portrayed both these women in their white gowns and in the mid-1780s he painted a full-length pastoral portrait of Elizabeth Linley, Mrs Sheridan, seated in the countryside with her clothes and lightly-curled hair blowing naturally in the wind.[5]

In 1774 the 'back to nature' enthusiasts were entertained by the arrival in London of Omai, a Polynesian islander brought to England by Captain Cook on the return of his second Pacific voyage. Omai was introduced at Court and invited to house parties at country estates. He was admired for his good looks and his innate grace and dignity, qualities that are to the fore in Reynolds's great portrait of him that was seen at the Academy in 1776. The Covent Garden theatre production *Omai; or, a Trip round the World*, with elaborate sets by de Loutherbourg, played for a remarkable forty nights in its first season in 1785.

Reynolds's account books show that in the 1770s he devoted an increasing amount of time to working from child models, beggars and workmen such as the pavior George White.[6] Gainsborough had painted fancy figures, at intervals, all his life. Early examples, such as the *Peasant with a Donkey* (no. 26) which is represented here by an engraving, are based on the Dutch tradition and make no concessions to elegance or classicism.[7] Throughout the 1760s and 70s he combined small-scale fancy figures with landscape (no. 16), making his peasants ever more idealized.

The first life-sized fancy figure that he exhibited was a *Shepherd Boy*, seen at the Academy in 1781. This move to larger figures was probably prompted by the activities of Reynolds and fuelled by Gainsborough's admiration for Murillo. Only a year or so earlier he had made a copy of Murillo's *Christ Child as the Good Shepherd*, a painting that appeared at Christie's (next door to Schomberg House) in 1778. The *Shepherd Boy* is based on Murillo's *Invitation to the Game of Pelota*, a picture also then in London.[8] The *Shepherd Boy*, which was lost in a house fire and is now only known through a mezzotint, was described in the press as 'equal to any picture produced by any modern artist, and superior to most'.[9] The *Girl with Pigs* (no. 25) was similarly well-received at the Academy in 1782. One reviewer considered it 'the best picture in the present exhibition. The pigs are beyond example beautiful, and the whole landscape is in that delightful stile, which has so justly raised [Gainsborough] to the distinction which he holds in the English schools.'[10] In 1781 one commentator tried to account for the success of such pictures. Writing about the *Shepherd Boy* he mused,

> As this Picture seems to have met with the Approbation of the Publick above all others, I must endeavour to find out from what it proceeds. It is from the representation of a familiar Object; it is placed in a simple and expressive Posture; the Face is handsome, and the Colouring beautiful.[11]

Thomas Hearne, in conversation at Dr Monro's, spoke in similar terms. He observed that in Gainsborough's pastoral subjects 'a strong sentiment always prevails. He exhibits familiar scenes, but His representations of simple life are given with

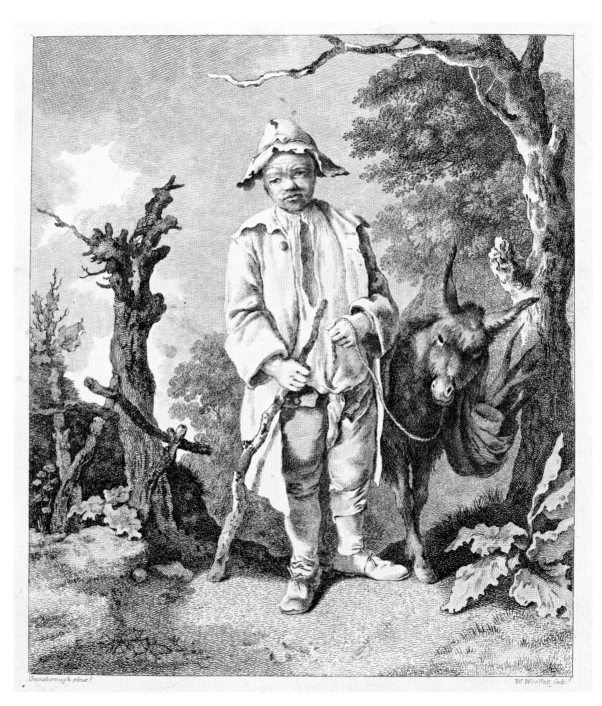

Gainsborough pinx.t W. Woollett sculp.t

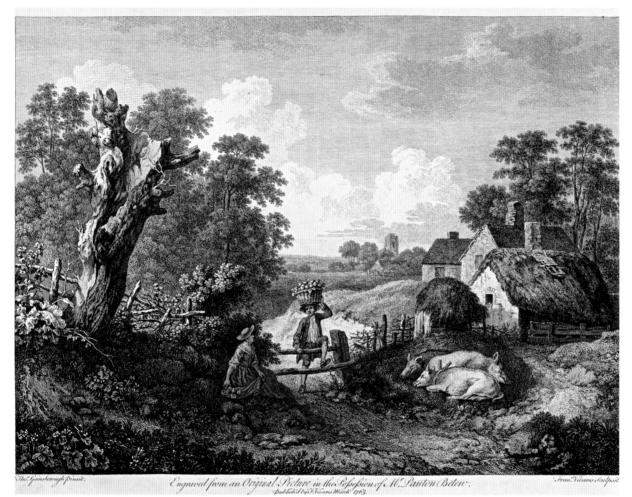

Thos. Gainsborough Pinxit. Engraved from an Original Picture in the Possession of Mr. Panton Betew. Fran.s Vivares Sculpsit.
Published by F. Vivares March 1763.

27. François Vivares
(1709–80) after Thomas
Gainsborough
*Landscape with Apple
Gatherers and Pigs*
Reproduced courtesy of
the lender

(opposite)
28. *Two Girls with Bundles
of Sticks*, 1785–88
Reproduced courtesy
of the lender

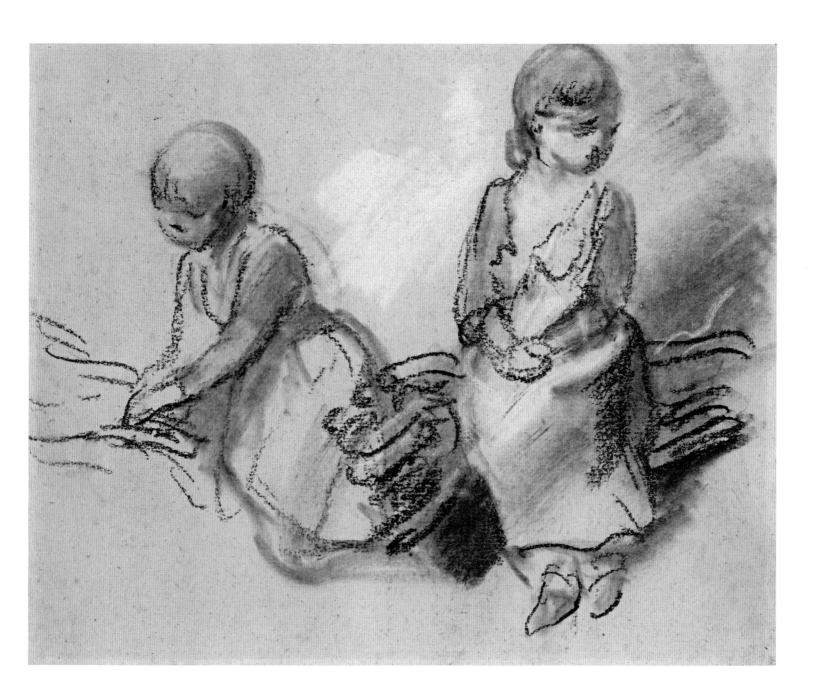

Fig.21 *Study of a little Girl, seated*, 1780–85
Black chalk and stump and white chalk on buff paper, 23.7 x 18.4 cm
Huntington Art Collections. 59.55.556
Reproduced courtesy of the Huntington Library, Art Collections, and Botanical Gardens, San Marino, California

(opposite)
Fig.22 *Landscape with a Cottage, Housemaid and Girl with Pigs*, 1786
Oil on canvas, 98.4 x 123.8 cm
Colchester and Ipswich Museum Service.
IPSMG:R.1982-91
Reproduced with the kind permission of Colchester and Ipswich Museum Service

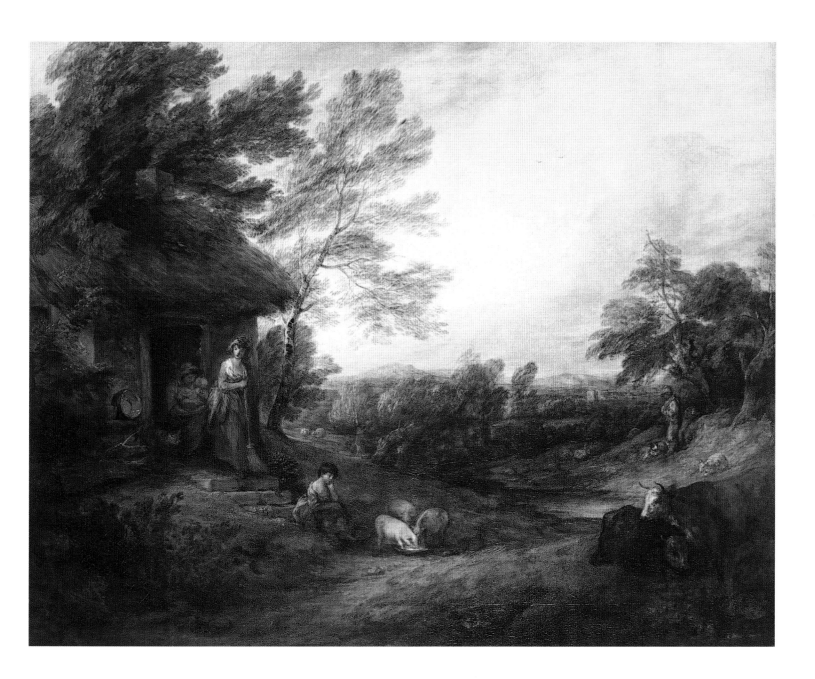

672

such taste as to delight and never offend'.[12] John Hoppner contrasted John Opie's 'vulgar' rustic figures with Gainsborough's, deploring the fact that Opie's excited in the viewer 'the lowest Ideas'.[13] Gainsborough's fancy pictures represent the peak of this genre in English art. The works of Hoppner, Richard Westall, Francis Wheatley and others who were influenced by Gainsborough are balanced precariously on the divide between good and bad taste, sentiment and sentimentality.

In preparing the *Girl with Pigs* Gainsborough worked from real animals let loose in his painting room at Schomberg House.[14] He only rarely drew pigs and the only previous painting in which they made a significant appearance was a landscape of the mid-1750s, now lost and illustrated here in the form of an engraving by François Vivares, published in 1765 (no. 27). The child in the *Girl with Pigs* is, like the pigs, based on life studies. Gainsborough made a number of rapid sketches of similar children, usually in chalk and stump (no. 28 and fig. 21), but the figure in the painting is more artfully posed. Her seated, head-on-hand attitude is one that was traditionally associated with melancholy. A very similar pose was used by Joseph Wright of Derby for his *Maria*, from Laurence Sterne's *A Sentimental Journey*. Wright's first painting of Maria dates from 1777, and his second slightly different treatment of the same subject was shown at the Academy in 1781, a year before Gainsborough's *Girl with Pigs*.[15] Angelica Kauffman (1740–1807) portrayed Maria in a similar fashion. A stipple engraving after Kauffman's design was published in 1779 and quickly became immensely popular; it was reproduced on a host of household items from watch cases to tea-trays.[16]

Gainsborough was probably familiar with the appearance of a classical relief known as the *Weeping Dacia* that is the source for many of these English representations of melancholy. A drawing by Sir William Chambers of this seated mourning figure is in Chambers's 'Franco-Italian Album', now in the Victoria and Albert Museum.[17]

One suspects that the *Girl with Pigs* was originally a slightly larger painting than it is now, as the mezzotint from it by Valentine Green and Richard Earlom, which dates from 1783, shows more room to the left and right of the figures.[18] The same girl and pigs were painted again by Gainsborough, this time with a great deal more space around them, in 1786 (fig. 22). Here, additional figures and cattle are introduced and more of the cottage on the left can be seen. The standing young woman with a broom outside the cottage door is the so-called 'housemaid', a figure Gainsborough also started to paint at full size on a canvas now at Tate Britain.[19] At this late date in his career Gainsborough was experimenting with a range of variations on the *Girl with Pigs* theme, and a drawing in the Victoria and Albert Museum (no. 29) has the same housemaid figure seated, resting her head on her hand, echoing the pose of the little girl. This beautiful drawing may have been made in the process of working out the second *Girl with Pigs* composition, or perhaps as a prelude to another unrealized fancy painting. A further associated drawing, now lost, once belonged to Gainsborough's family and was reproduced as a lithograph by his great-nephew Richard Lane in 1825 (fig. 23).[20] This shows a similar seated girl or young woman transformed into a water-carrier and no longer imitating the *Weeping Dacia* pose.

Following its appearance in the Royal Academy exhibition of spring 1782, the *Girl with Pigs* was purchased by Sir Joshua Reynolds for one hundred guineas. Gainsborough wrote in appreciation to Reynolds, 'I think myself highly honor'd, & much Obliged to you for this singular mark of your favor; I may truly say that I have brought my Piggs to a fine market'.[21] To make sense of this we must add emphasis to the word *truly*, since to bring one's pigs to a fine market was a saying, then in common usage, meaning that one had failed in business.[22]

This short essay on the *Girl with Pigs* opened with Gainsborough joking to Chambers about his avoidance of serious subjects; it ends with him joking with Reynolds about the sale of the picture. It is characteristic of him to make light of weighty subjects, and, despite his protestations, he attached great importance to his fancy pictures. It was his last large fancy picture, *The Woodman*, that Gainsborough begged Reynolds to come and see when he lay dying in July 1788.[23]

NOTES

1 Hayes 2001, no. 91, p. 152, to Sir William Chambers, 27 April 1783.
2 Postle 1998, p. 9.
3 *The Diary; or, Woodfall's Register*, issue 10, 9 April 1789, p. 3.
4 W.S. Lewis, *Three Tours through London in the Years 1748, 1776, 1797*, New Haven 1941, pp. 55–56.
5 Waterhouse 1966, no. 579, p. 87; no. 194, p. 63 and no. 613, p. 89.
6 Postle 1998, under no. 25, p. 68.
7 The painting on which Woollett's etching is based measures approximately 48 x 38 cm (18 7/8 x 14 15/16 in); it is reproduced in Hayes 1982, I, fig.102, p. 81 and in Postle 1998, fig.48, p. 23.
8 Postle 1998, no. 7, pp. 59–60, no. 6, p. 59.
9 *Morning Chronicle*, issue 3729, 1 May 1781, p. 3.
10 *General Advertiser, and Morning Intelligencer*, issue 1737, 3 May 1782, p. 3.
11 *St James's Chronicle*, issue 3151, 10–12 May 1781, p. 4.
12 Farington 1978–98, X, p. 3506, entry for 5 July 1809.
13 Ibid., V, p. 1973, entry for 4 February 1803.
14 W.T. Parke, *Musical Memoirs, comprising an Account of the General State of Music in England*, 2 vols., London 1830, II, pp. 107–8.
15 Judy Egerton, *Wright of Derby*, exhibition catalogue, Tate Gallery and elsewhere 1990, no. 52, pp. 106–7; no. 58, p. 115.
16 Timothy Clayton, *The English Print 1688–1802*, New Haven and London 1997, p. 246 and fig.265, p. 247.
17 Sir William Chambers, 'The Franco-Italian Album', Victoria and Albert Museum, London, 5712.285, fol.60.
18 Belsey 2002, no. 43, p. 94.
19 Waterhouse 1966, no. 811, p. 104.
20 The lost drawing is Hayes 1970, I, no. 848, p. 307.
21 Hayes 2001, no. 88, to Sir Joshua Reynolds, undated but 1782.
22 Burton Stevenson, *Stevenson's Book of Proverbs, Maxims and Familiar Phrases*, London 1949, p. 1529; Elizabeth Knowles, ed., *The Oxford Dictionary of Phrase, Saying, and Quotation*, Oxford 1997, p. 422.
23 Hayes 2001, no. 110, p. 176, to Sir Joshua Reynolds, July 1788. *The Woodman* was lost in the same house fire at Exton Park in 1810 as the *Shepherd Boy*.

6. 'Rocks and Water-falls'

THE LANDSCAPE GIVEN by Gainsborough's daughter to the Royal Academy (no. 30) is one of the artist's most haunting images. Martin Myrone has justifiably called it a 'monumental and fantastical' painting.[1] Gainsborough had a fractious relationship with the Royal Academy but at heart he respected the institution and knew the value of being represented on its walls. There seems no reason to doubt Margaret Gainsborough's word when she said in 1799 that she sent the picture 'in compliance with the intention of her late father'.[2] This is evidently a landscape by which Gainsborough wished to be remembered.

When it was exhibited at the British Institution in 1814 the picture was entitled 'Romantic Landscape', a fitting name that is for convenience used here. By the 1780s, when Gainsborough came to paint it, he had long been preoccupied with the romance of mountain scenery. He wrote in 1768 to his former banker James Unwin, who had recently moved to the borders of Derbyshire, 'I suppose your Country is very woody – pray have you Rocks and Water-falls? for I am as fond of Landskip as ever'.[3] Having grown up in the flat landscape of East Anglia, he had reacted with obvious pleasure to the very different scenery around Bath when he moved there at the end of the 1750s. Within a few miles of

that city he found rocky outcrops left by open cast stone mining, and densely wooded hills, but even Bath could not offer the more dramatic landscape he craved. His appetite for mountains was probably whetted by his friend Robert Price (1717–1761), father of Uvedale Price, who was one of the first Englishmen to make careful drawings of glaciers and mountains in the Alps.[4] Robert Price also made a tour of Welsh waterfalls in 1759 and drew each one in a gentle pencil and ink wash technique.[5] Like any other artist of the period, Gainsborough would have been familiar with the mountain landscapes of Salvator Rosa with their threatening rocks and wind-blown trees. One of Rosa's pictures of an inhospitable rocky landscape was engraved in 1744 by Joseph Wood, the printmaker who helped Gainsborough with his early attempts at etching.[6] Even if he had not seen the Rosa print in Wood's studio, Gainsborough would have known it, as it belonged to a series of engravings of Continental landscapes published by Arthur Pond and widely distributed in the 1740s. Another of the paintings that was engraved for this series, a *Landscape with Bathers* by Gaspard Dughet, belonged to Robert Price.[7]

If Gainsborough's ideas about mountainous landscape developed early on, he may not have personally witnessed any genuinely wild scenery until he travelled

31. *Mountainous Landscape with a Boat on a Lake or River*, 1775–80
© Birmingham Museums & Art Gallery

32. Mountain Landscape with Figures and Sheep, 1782–83
Reproduced courtesy of the Trustees, Cecil Higgins Art Gallery, Bedford

33. *Rocky Landscape with Shepherd and Flock of Sheep*, 1780–85
Reproduced courtesy of Leeds Museums and Galleries (City Art Gallery) U.K. / The Bridgeman Art Library

to the Lake District in 1783. That excursion came at a time when he was already devoting a great deal of energy to the drawing and painting of rocks, cliffs and mountains. The Birmingham drawing shown here, which includes jutting rocks and a lake or river and fishermen, seems to incorporate some changes of mind or experimentation (no. 31). It is dated by Hayes to around 1778. The chalk drawing from Bedford (no. 32) is a design for a large mountainous

landscape that was exhibited at the Royal Academy in 1783, several months before the trip to the Lakes.[8] A third drawing that includes the flock of sheep seen in the *Romantic Landscape* is now at Leeds (no. 33); this may have been made before or after the painting.

It is difficult to say exactly when the *Romantic Landscape* was painted, and it may have been in production over a long period, like the landscape with horses and cattle called *Repose* (fig. 10). According

to the Minutes of the Council of the Royal Academy, on 13 September 1787 'Mr Garvey reported that Mr Gainsborough had promised to paint a Picture for the Chimney in the Council Room in the Place of that formerly proposed to be painted by Mr Cipriani'.[9] Since the opening in 1780 of Sir William Chambers's new rooms of the Royal Academy in Somerset House, a steady stream of pictures had been donated and some *in situ* wall painting carried out by Academicians. In 1780 the Council Room contained only portraits of the King and Queen by Reynolds and a *Samuel and Eli* by John Singleton Copley, but the walls of this prestigious space quickly began to fill. The foundation members of the Academy, who had been nominated in 1769, were not required to give an example of their work, but from 1770 every new Academician had to do so on election. Not wishing to be omitted, a number of foundation members decided to contribute retrospectively. Giovanni Battista Cipriani, who was one of these, had evidently offered an overmantel for the Council Room, but he died at the end of 1785 without having painted it. Edmund Garvey's message to the Academy suggests that Gainsborough was reacting to Cipriani's death, but there are two chimney breasts in the Council Room, and it is possible that Gainsborough always intended to provide a picture for one of these spaces. He may have vacillated after losing his temper with his fellow Academicians in 1784 when he objected to the positioning of his pictures in the annual exhibition in the Great Room. Intimations of his own mortality seem to have prompted the offer in September 1787. In June of that year his dearest friend the musician Carl Friedrich Abel died. Informing Henry Bate of Abel's death, Gainsborough spoke of his desolation and of 'the little while I have to stay behind'.[10] Whether the *Romantic Landscape* was always the picture he intended to give is an unanswerable question, but it is ideally formed to fit the overmantel space. In its present frame the picture measures just over 221 cm in width: the marble chimney piece beneath, which was designed by Joseph Wilton, is 228 cm wide.

Compositionally the *Romantic Landscape* has its roots in the 1770s. It evolves out of the design of the *Watering Place* (no. 20). The two pictures have essentially the same subject: animals being taken to water. In both cases the landscape is moulded into a bowl-like hollow that shelters the figures and animals and, at the same time, isolates them from the outside world. Ann Bermingham, writing about the *Watering Place*, says,

> In Gainsborough, the simple way of life becomes associated exclusively with the remote, at times almost primordial, countryside and with its humblest inhabitants. In these rustic landscapes Gainsborough explores … an unmediated and organic relationship between man and nature, as though isolation from urban culture were an essential prerequisite for such a relationship.[11]

If anything, the Royal Academy picture has more of a primordial atmosphere than the *Watering Place*. At the same time it contains some charming detail in the form of the goat climbing up to drink and the young shepherd boys, one of whom is playing with his dog. These moments of levity in an otherwise heavyweight picture take us back to the *River Landscape* of 1750 (no. 6) with its dawdling milkmaid and barking dog. The connection between the *Watering Place* and the *Romantic Landscape* is illustrated

(opposite)
35. *Rocky Landscape with Shepherd, Sheep and Cattle at a Pool*, c.1785
Reproduced by kind permission of The Provost & Fellows of Eton College

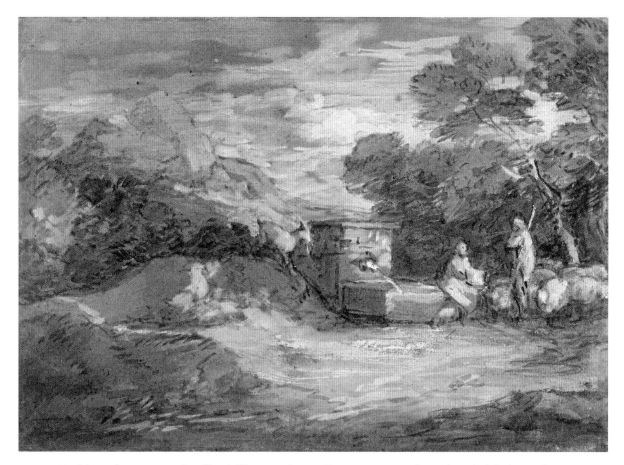

Fig.24 *A Mountain Landscape with Figures and Sheep by a Fountain*, 1785–88
Grey wash, oil and black chalk, varnished, 21.3 x 30 cm
Yale Center for British Art, Paul Mellon Collection/
The Bridgeman Art Library

in a magical late drawing in the Cecil Higgins Art Gallery, Bedford (no. 34) and another at Eton (no. 35). In the Bedford drawing the great looming rock on the left started out as a tree and was turned to stone as the artist applied wash and chalk to the paper. The Eton study shows how far Gainsborough was prepared to depart from reality in order to create the right balance of shapes and tones. This drawing ostensibly depicts cows and sheep watering, but the sheep are not credible as animals. Their sole *raison d'être* is to introduce dappled light and a sweeping curve to the left side of the picture.

As to the symbolism of rocks and mountains, and the meaning of a picture such as the *Romantic Landscape* (if it has a meaning beyond the obvious formal and painterly one) it is worth remembering that Gainsborough's only overtly Biblical picture dates from this period. As we saw from his letter to Jackson, he ridiculed the idea of painting a *Flight into Egypt* in 1767, but in the mid-1780s he happily

painted *Hagar and Ishmael in the Wilderness*, now in the National Museum of Wales.[12] The Biblical landscape in which he sets the exiled Hagar and her son is a rocky and wooded place, no different from the wilderness depicted in the *Romantic Landscape*.[13] Hagar and Ishmael wander in search of water, like the animals in other pictures. A drawing from the Yale Center for British Art (fig. 24) that can be associated with the *Romantic Landscape* depicts figures and animals at a fountain. This drawing is reminiscent of depictions by Poussin and others of *Christ and the Woman of Samaria at the Well*, and *Rebecca at the Well*. The rock is an image much exploited in the Old and New Testaments. Moses struck a rock to provide water for the children of Israel; Christ named his disciple Peter, which means a rock, in anticipation of his role as leader of the church. Drawing on this imagery, the eighteenth-century poet Oliver Goldsmith used a cliff as a metaphor for the charitable clergyman watching over his flock in *The Deserted Village*:

> His ready smile a parent's warmth expresst,
> Their welfare pleas'd him, and their care distresst.
> To them his heart, his love, his griefs were given,
> But all his serious thoughts had rest in heaven.
> As some tall cliff that lifts its awful form
> Swells in the vale, and midway leaves the storm,
> Tho' round its breast the rolling clouds are spread,
> Eternal sun-shine settles on its head.[14]

The *Romantic Landscape* is a painting that is not in perfect condition, but the composition is much more legible than it once was, and it is undoubtedly a major treasure of the Royal Academy collection.[15] If the fancy pictures transcend time, Gainsborough's landscapes transcend place. The vision of the 'primordial countryside' that they encapsulate was achieved by overlaying observations of nature with a whole range of influences, from Wijnants and Ruisdael to Claude and Rubens. Gainsborough's own method of composition, or what he called 'grouping in the mind' then allowed him to arrive at 'one grand whole, peculiarly his own, and peculiarly excellent'.[16]

NOTES

1 Rosenthal and Myrone 2002, p. 248.

2 Hayes 1982, II, no. 138, p. 503.

3 Hayes 2001, no. 31, p. 53, to James Unwin, from Bath, 25 May 1768.

4 Sloman 2002, pp. 155–56.

5 Ibid., p. 157. Price's waterfalls were probably influenced by John Boydell's series of prints of Welsh waterfalls, published in 1750.

6 The print is reproduced in John Dixon Hunt, *The Picturesque Garden in Europe*, London 2004 (first published 2002), pp 26–27.

7 Sloman 2002, fig.133, p. 153.

8 Hayes 1982, II, no. 137, pp. 501–2. The painting is in the National Gallery of Scotland; a sketchier version is now in Cleveland, Ohio, ibid., no. 136, pp. 500–1.

9 Royal Academy, London, 'Minutes of the Council of the Royal Academy, II, 1784–1798', p. 45.

10 Hayes 2001, no. 101, p. 164.

11 Bermingham 1987, p. 41.

12 The letter to Jackson is quoted above, on p. 54. *Hagar and Ishmael* is catalogued in Hayes 1982, II, no. 186, pp. 572–74. In Rosenthal and Myrone 2002, no. 180, pp. 284–85 Rosenthal discusses this picture and notes that 'we might review some of Gainsborough's more ostensibly secular subjects in the light of his faith'.

13 Around 1770 de Loutherbourg had also depicted Hagar and Ishmael as a pastoral subject, see Rüdiger Joppien, *Philippe Jacques de Loutherbourg, RA*, exhibition catalogue, Iveagh Bequest, Kenwood, 1973, no. 56 (no page numbers).

14 Oliver Goldsmith, *The Deserted Village, A Poem*, London (undated, first published 1770), p. 19.

15 Hayes seemed to dislike the picture and referred to some early restoration (Hayes 1982, II, p. 505), but its appearance at the 2002 Gainsborough show at the Tate was a revelation (to this author at least).

16 *Morning Chronicle*, issue 6006, 8 August 1788, p. 3.

Lenders to the exhibition

Ashmolean Museum, Oxford

His Grace the Duke of Bedford and the Trustees
 of the Bedford Estates

Birmingham Museum and Art Gallery

The British Museum, London

Castle Howard Collection

Trustees Cecil Higgins Art Gallery, Bedford, England

Colchester and Ipswich Museum Service

The Samuel Courtauld Trust, The Courtauld Gallery,
 London

Edinburgh, National Galleries of Scotland

English Heritage, The Iveagh Bequest, Kenwood,
 London

The Provost & Fellows of Eton College

Trustees of Gainsborough's House Society, Suffolk

Leeds Museums and Galleries (Leeds Art Gallery)

Manchester City Galleries

National Gallery, London

Royal Academy of Arts, London

Tate

Victoria and Albert Museum

The Hepworth Wakefield

and others who wish to remain anonymous

Catalogue

Catalogue note: all works are by Thomas Gainsborough (1727–1788) unless stated otherwise. The key to abbreviated references is to be found in the Bibliography on p. 109.

Gainsborough's Landscapes: Themes and Variations

1 John Sebastian Müller (1720–after 1760) after Joshua Kirby (1716–1774)

A Variety of Figures …[containing] all the Rules and Principles of Perspective, from Joshua Kirby, *Dr Brook Taylor's Method of Perspective made Easy… in two Books* (bound as one) Ipswich 1754, Book II, open at fig.70, between pp. 58–59
Engraving
20.2 x 16.5 cm (8 x 6 ¹/₂ in) (image); 25.4 x 19.7 cm (10 x 7 ³/₄ in) page size
Royal Academy of Arts, London. 03/2826
© The Royal Academy of Arts, London; photographer Prudence Cuming Associates

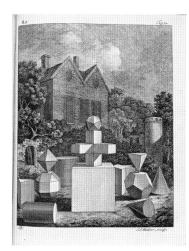

2 *Self-portrait*, c.1755

Pencil on two sheets of paper
35.9 x 28.5 cm (14 ¹/₈ x 11 ¹/₄ in)
British Museum, London. 1988,0305.59
Hayes 1970, I, no. 15, p. 113; Belsey 2008, p. 438
© The Trustees of the British Museum

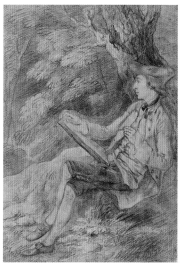

3 *Study of a Bridge*, 1750–55

Pencil
14 x 18.7 cm (5 ¹/₂ x 7 ³/₈ in)
British Museum, London. 00,2.47
Hayes 1970, I, no. 147, p. 146
© The Trustees of the British Museum

4 *Wooded Landscape with Cattle crossing a Bridge*, 1780

Soft-ground etching
30 x 39.4 cm (11 $^{13}/_{16}$ x 15 $^{1}/_{2}$ in)
 to plate mark
British Museum, London.
 1852,0705.229
Hayes 1971, no. 11, p. 75
© The Trustees of the British
 Museum

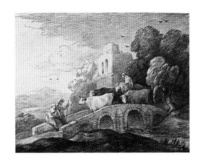

5 *Landscape with Cattle and Castle Ruin*, 1785–88

Black and white chalks, ink and
 watercolour wash
21.9 x 31.6 cm (8 $^{5}/_{8}$ x 12 $^{7}/_{16}$ in)
Ashmolean Museum, Oxford.
 Purchased 1951, WA 1951.153
Hayes 1970, I, no. 761, p. 283
Reproduced courtesy of the
 Ashmolean Museum, Oxford

1 'Nature is modest'

6 *River Landscape with a View of a distant Village*, c.1750

Oil on canvas
75 x 151 cm (29 $^{1}/_{2}$ x 59 $^{1}/_{2}$ in)
Edinburgh, National Galleries of
 Scotland. NG2174
Hayes 1982, II, no. 29, pp. 368–59
Reproduced courtesy of the National
 Gallery of Scotland

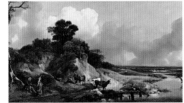

7 *Two Ladies Walking Arm-in-Arm*, 1751–52

Pencil
22.4 x 16.5 cm (8 $^{7}/_{8}$ x 6 $^{1}/_{2}$ in)
Signed 'fe. TG'
Private collection
Belsey 2008, no. 1109, p. 528
Reproduced courtesy of the lender

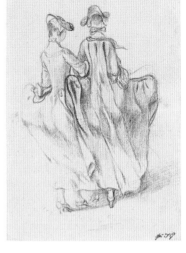

8 *Landscape with Shepherd and Sheep on a Hillock*, c.1750

Pencil
14.3 x 18.7 cm (5 $^{5}/_{8}$ x 7 $^{3}/_{8}$ in)
The Samuel Courtauld Trust,
 The Courtauld Gallery, London.
 D.1952.RW.3950
Hayes 1970, I, no. 166, p. 150
Reproduced courtesy of The Samuel
 Courtauld Trust, The Courtauld
 Gallery, London

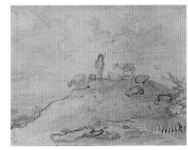

9 *Mountainous Landscape with Shepherd and Sheep*, c.1783

Black chalk and stump and white
 chalk on buff paper
25.1 x 34.1 cm (9 $^{7}/_{8}$ x 13 $^{7}/_{16}$ in)
Birmingham Museums and Art
 Gallery. 1935P89
Hayes 1970, I, no. 772, p. 285
© Birmingham Museums & Art
 Gallery

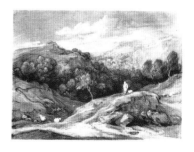

10 By or after Thomas Gainsborough
River Landscape with Sheep,
*c.*1785

Soft-ground etching with aquatint
29.1 x 38.1 cm (11 $^7/_{16}$ x 15 in)
 to plate mark
Tate. Presented by A.E. Anderson
 1910. N02720
Hayes 1971, I, no. 13, p. 81
© Tate, London 2011

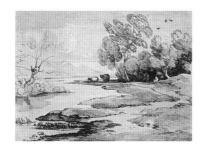

11 *Upland Landscape with*
River and Horsemen crossing
a Bridge, 1785–88

Black chalk and stump and white
 chalk on buff paper
26.4 x 36.8 cm (10 $^3/_8$ x 14 $^1/_2$ in)
Tate. Presented by T. Birch Wolfe
 1878. N02226
Hayes 1970, I, no. 788, p. 289
© Tate, London 2011

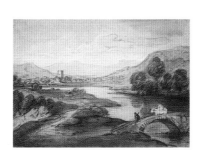

2 'Quietness & ease'

12 *Wooded Landscape with two*
Carthorses, 1755

Oil on canvas
92.5 x 103 cm (36 $^3/_8$ x 40 $^1/_2$ in)
His Grace the Duke of Bedford and
 the Trustees of the Bedford Estates,
 Woburn Abbey. I.N.1465
Hayes 1982, II, no. 51, pp. 384–86
Reproduced courtesy of His Grace
 the Duke of Bedford and the
 Trustees of the Bedford Estates

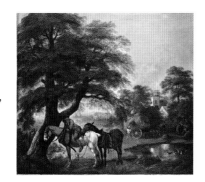

13 *Wooded Landscape with*
Horses resting, 1775–80

Black and white and coloured chalks
 on grey paper
25.1 x 30.2 cm (9 $^7/_8$ x 11 $^7/_8$ in)
Tate. Presented by T. Birch Wolfe
 1878. N02227
Hayes 1970, I, no. 403, p. 202
© Tate, London 2011

14 *Wooded Landscape with*
Milkmaids and Cows,
1785–88

Chalks and grey wash on buff paper
25.4 x 30.5 cm (10 x 12 in)
Colchester and Ipswich Museum
 Service. IPSMG:R.1917-12.3
Hayes 1970, I, no. 696, p. 268
Reproduced by kind permission
 of Colchester and Ipswich
 Museum Service

15 *Wooded Landscape with*
Horses drinking at a Trough,
1785–88

Black chalk, grey wash and oil on
 brown prepared paper, varnished
22.4 x 29.2 cm (8 $^{13}/_{16}$ x 11 $^1/_2$ in)
Private collection
Hayes 1970, I, no. 726, p. 275
Reproduced courtesy of the lender

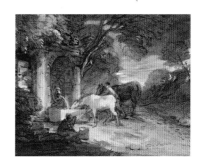

3 'Charity and humane feelings'

16 *Landscape with Travellers returning from Market*, c.1770

Oil on canvas
122.3 x 150 cm ($48\,^{3}/_{16}$ x $59\,^{1}/_{16}$ in)
The Iveagh Bequest, London
 (English Heritage)
Hayes 1982, II, no. 95, pp. 438–40
© English Heritage Photo Library

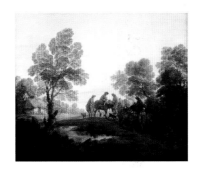

17 *Wooded Landscape with Packhorses*, 1770–75

Black chalk, white chalk and water-
 colour on toned paper, varnished
21.1 x 30.3 cm ($8\,^{15}/_{16}$ x $11\,^{15}/_{16}$ in)
Stamped with monogram 'TG'
Birmingham Museums and Art
 Gallery. 1953P211
Hayes 1970, I, no. 333, p. 186
© Birmingham Museums &
 Art Gallery

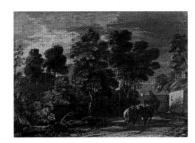

18 *Landscape with Travellers on Horseback and a Cottage*, 1780–85

Grey wash and oil on brown
 prepared paper, varnished
21.6 x 31.1 cm ($8\,^{1}/_{2}$ x $12\,^{1}/_{4}$ in)
The British Museum, London.
 PD Gg,3.392
Hayes 1970, I, no. 511, p. 227
© The Trustees of the British
 Museum

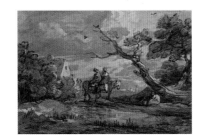

19 *Landscape with Figures on Horseback*, 1780–85

Brown wash over an 'offset' line
19.4 x 26.4 cm ($7\,^{5}/_{8}$ x $10\,^{3}/_{8}$ in)
British Museum, London.
 1868,0328.313
Hayes 1970, I, no. 587, pp. 244–45
© The Trustees of the British
 Museum

4 'The mild Evening gleam'

20 *The Watering Place*, 1774–77

Oil on canvas
147.3 x 180.3 cm (58 x 71 in)
The National Gallery, London.
 Presented by Charles Long MP,
 later Lord Farnborough, 1827.
 NG 109
Hayes 1982, II, no. 117,
 pp. 465–67
© The National Gallery, London

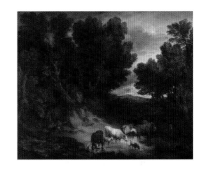

21 *Landscape with a Cottage, a Herdsman and Cow*, c.1750

Pencil
22.1 x 29.6 cm ($8\,^{11}/_{16}$ x $11\,^{5}/_{8}$ in)
Gainsborough's House Society,
 Sudbury. 1990.051
Belsey 2008, no. 1022, pp. 474–75
Reproduced courtesy Gainsborough's
 House, Sudbury, Suffolk

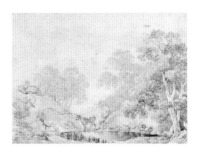

22 *Wooded Landscape with Figure and Cattle*, 1770–75

Watercolour and oil on two sheets
 of paper laid down on to canvas
43 x 58 cm (16 $^{15}/_{16}$ x 22 $^{7}/_{8}$ in)
The Hepworth Wakefield. A1.574
Hayes 1970, I, no. 367, p. 194
Reproduced courtesy of
 The Hepworth Wakefield

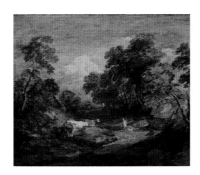

23 *Wooded Landscape with Horsemen travelling along a Country Track*, 1775–80

Black and white and coloured chalks
 on blue-grey paper
25.4 x 31.4 cm (10 x 12 $^{3}/_{8}$ in)
Tate. Presented by T. Birch Wolfe
 1878. N02225
Hayes 1970, I, no. 409, p. 204
© Tate, London 2011

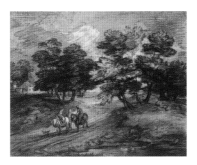

24 *Wooded Landscape with Horses, Cart and Figures*, 1785–88

Black chalk and stump and white
 chalk on blue paper
18.3 x 21.7 cm (7 $^{3}/_{16}$ x 8 $^{9}/_{16}$ in)
Manchester City Galleries. 1953.1
Hayes 1970, I, no. 595, p. 246
© Manchester City Galleries

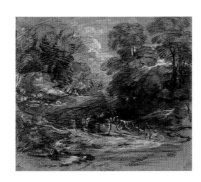

5 'Avoiding great subjects'

25 *Girl with Pigs*, 1781–82

Oil on canvas
125.7 x 148.5 cm (49 $^{1}/_{2}$ x 58 $^{1}/_{2}$ in)
From the Castle Howard Collection
Waterhouse 1966, no. 799, p. 103
Image from the Castle Howard
 Collection

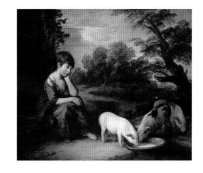

26 William Woollett
(1735–1785) after Thomas
Gainsborough
Peasant with a Donkey

Engraving after a painting of *c.*1755
26.5 x 22.8 cm (10 $^{3}/_{8}$ x 9 in) to
 plate mark
British Museum, London.
 1857.0110.8
Waterhouse 1966, no. 816a, p. 105
 (the painting)
© The Trustees of the British
 Museum

27 François Vivares
(1709-1780) after Thomas
Gainsborough
*Landscape with Apple Gatherers
and Pigs*

Engraving, 1765, after a painting
 of 1755–57
28 x 37.5 cm (11 x 14 $^{3}/_{4}$ in) to
 plate mark
Private collection
Hayes 1982, II, no. 60, pp. 395–96
 (the painting)
Reproduced courtesy of the lender.
 Photograph by Daniel Brown

28 *Two Girls with Bundles of Sticks*, 1785–88

Black chalk and stump and
 white chalk
25.4 x 30.5 cm (10 x 12 in)
Private collection
Hayes 1970, I, no. 842, p. 305;
 Hayes 1983, no. 980, p. 390;
 Belsey 2008, p. 455
Reproduced courtesy of the lender.
 Photograph by
 Matthew Hollow

29 *Study of a Housemaid, seated, c.*1785

Black chalk and stump and white
 chalk on grey paper
33 x 24.1 cm (13 x 9 $\frac{1}{2}$ in)
Victoria and Albert Museum,
 London. Dyce 672
Hayes 1970, I, no. 838, p. 304
© V&A Images/Victoria and
 Albert Museum, London

6 'Rocks and Water-falls'

30 *Mountainous Landscape with Shepherds and Sheep: 'Romantic Landscape'*, 1780–85

Oil on canvas
153.7 x 186.7 cm (60 $\frac{1}{2}$ x 73 $\frac{1}{2}$ in)
Royal Academy of Arts, London.
 03/1396
Hayes 1982, II, no. 138, pp. 503–5
© Royal Academy of Arts, London;
 photographer Prudence Cuming
 Associates

31 *Mountainous Landscape with a Boat on a Lake or River*, 1775–80

Grey and grey-black wash with
 white chalk on buff paper
27.3 x 36.7 cm (10 $\frac{3}{4}$ x 14 $\frac{7}{16}$ in)
Birmingham Museums and Art
 Gallery. 1953P189
Hayes 1970, I, no. 465, p. 216
© Birmingham Museums &
 Art Gallery

32 *Mountain Landscape with Figures and Sheep*, 1782–83

Black chalk and stump and white
 chalk on buff paper
25.7 x 35.2 cm (10 $\frac{1}{8}$ x 13 $\frac{7}{8}$ in)
Cecil Higgins Art Gallery, Bedford.
 P. 71
Hayes 1970, I, no. 564, p. 239
Reproduced courtesy of the Trustees,
 Cecil Higgins Art Gallery, Bedford

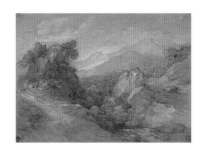

33 *Rocky Landscape with Shepherd and Flock of Sheep,* 1780–85

Pen and ink, ink wash and body-
 colour
26 x 34.6 cm (10 ¼ x 13 ⅝ in)
Leeds Museums and Galleries
 (Leeds Art Gallery).
 LEEAG.PA.1924.0562
Hayes 1970, I, no. 533, p. 232
Reproduced courtesy of Leeds
 Museums and Galleries (City Art
 Gallery) U.K. / The Bridgeman
 Art Library

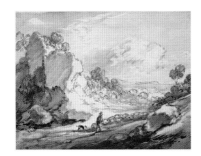

35 *Rocky Landscape with Shepherd, Sheep and Cattle at a Pool,* c.1785

Black and white chalks and grey
 wash on grey paper
26 x 34.5 cm (10 ¼ x 13 ⁹⁄₁₆ in)
Eton College, EC Pi 248
Hayes 1970, I, no. 751, p. 280
Reproduced by kind permission
 of The Provost & Fellows of
 Eton College

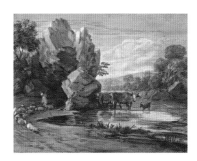

34 *Landscape with Packhorses descending to a Pool,* 1785–88

Black and white chalks with grey
 wash
31.7 x 45.1 cm (12 ½ x 17 ¾ in)
Cecil Higgins Art Gallery, Bedford.
 P. 314
Hayes 1970, I, no. 759, p. 282
Reproduced courtesy of the Trustees,
 Cecil Higgins Art Gallery, Bedford

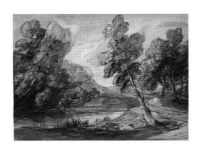

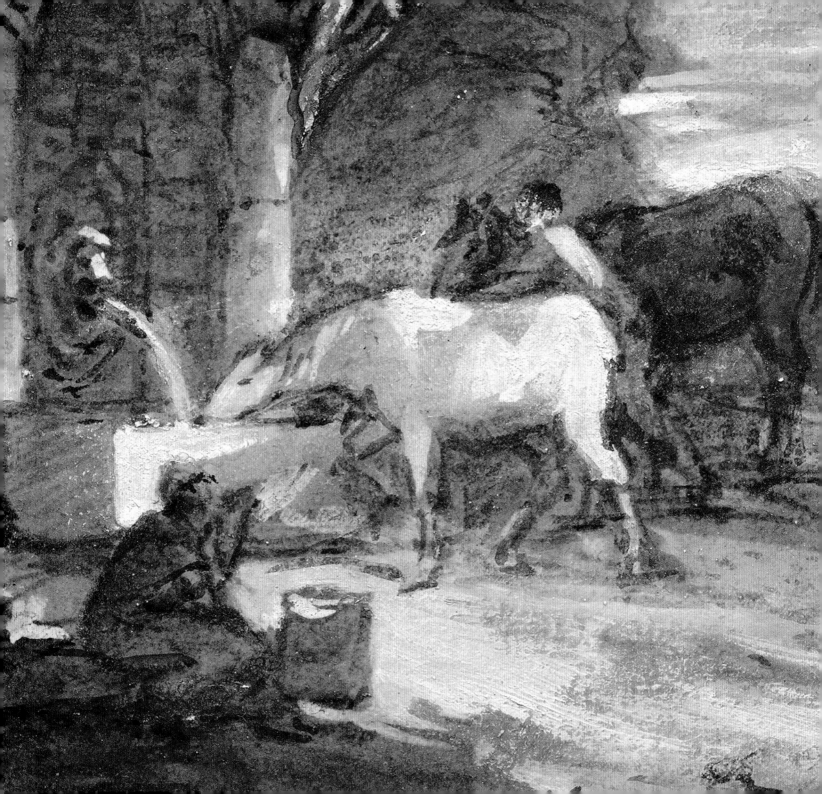

Bibliography

Angelo 1969: Henry Angelo, *The Reminiscences of Henry Angelo*, introduced by Lord Howard de Walden, with notes by H. Lavers Smith, 2 vols., New York and London 1969 (this edition first published 1904)

Belsey 2002: Hugh Belsey, *Gainsborough at Gainsborough's House*, exhibition catalogue, Thos. Agnew & Sons Ltd, London, and elsewhere, 2002

Belsey 2008: 'A Second Supplement to John Hayes's *The Drawings of Thomas Gainsborough*', *Master Drawings*, XLVI, no. 4, Winter 2008, pp. 427–541

Bermingham 1987: Ann Bermingham, *Landscape and Ideology: the English Rustic Tradition, 1740–1860*, London 1987

Bermingham 2005: Ann Bermingham, ed., *Sensation and Sensibility: Viewing Gainsborough's Cottage Door*, New Haven and London 2005

Clifford 1978: Timothy Clifford, Antony Griffiths and Martin Royalton-Kisch, *Gainsborough and Reynolds in the British Museum*, exhibition catalogue, British Museum, London 1978

Edwards 1808: Edward Edwards, *Anecdotes of Painters who have resided or been born in England*, London 1808

Farington 1978–98: Joseph Farington, *The Diary of Joseph Farington RA*, Kathryn Cave, Kenneth Garlick, Angus Macintyre and Evelyn Newby eds, 17 vols., New Haven and London 1978–98

Foister 1997: Susan Foister, *Young Gainsborough*, exhibition catalogue, National Gallery, London 1997

Fulcher 1856: George Williams Fulcher, *Life of Thomas Gainsborough, R.A.*, E.S. Fulcher, ed., London 1856

Hayes 1970: John Hayes, *The Drawings of Thomas Gainsborough*, 2 vols, London 1970

Hayes 1971: John Hayes, *Gainsborough as Printmaker*, London 1971

Hayes 1982: John Hayes, *The Landscape Paintings of Thomas Gainsborough*, 2 vols., London 1982

Hayes 1983: John Hayes, 'Gainsborough Drawings: A Supplement to the *Catalogue Raisonné*', *Master Drawings*, XXI, no. 4, Winter 1983, pp. 367–91

Hayes 2001: John Hayes, ed., *The Letters of Thomas Gainsborough*, New Haven and London 2001

Ingamells and Edgcumbe 2000: John Ingamells and John Edgcumbe, eds., *The Letters of Sir Joshua Reynolds*, New Haven and London 2000

Kidson 2002: Alex Kidson, *George Romney 1734–1802*, exhibition catalogue, National Portrait Gallery and elsewhere, 2002

Kirby 1754: Joshua Kirby, *Dr Brook Taylor's Method of Perspective made Easy…in two Books* (bound as one) Ipswich 1754

Morris and Milner 1985: David Morris and Barbara Milner, *Thomas Hearne 1744–1817*, exhibition catalogue, Bolton Museum and Art Gallery and elsewhere, 1985

Owen 1996: Felicity Owen, 'Joshua Kirby (1716–74): a biographical sketch', *Gainsborough's House Review 1995/96*, 1996, pp. 61–75

(opposite detail)
15. *Wooded Landscape with Horses drinking at a Trough*, 1785–88
Reproduced courtesy of the lender

Postle 1998: Martin Postle, *Angels and Urchins, The Fancy Picture in Eighteenth-Century British Art*, exhibition catalogue, University of Nottingham and elsewhere, 1998

Richardson 1773: Jonathan Richardson, *The Works of Jonathan Richardson*, Jonathan Richardson the Younger, ed., London 1773

Rosenthal 1999: Michael Rosenthal, *The Art of Thomas Gainsborough: 'a little business for the Eye'*, New Haven and London 1999

Rosenthal and Myrone 2002: Michael Rosenthal and Martin Myrone eds, *Gainsborough*, exhibition catalogue, Tate Britain and elsewhere, 2002

Sloman 2002: Susan Sloman, *Gainsborough in Bath*, New Haven and London 2002

Waterhouse 1966: Ellis Waterhouse, *Gainsborough*, London 1966 (first published 1958)

Whitley 1915: William Whitley, *Thomas Gainsborough*, London 1915